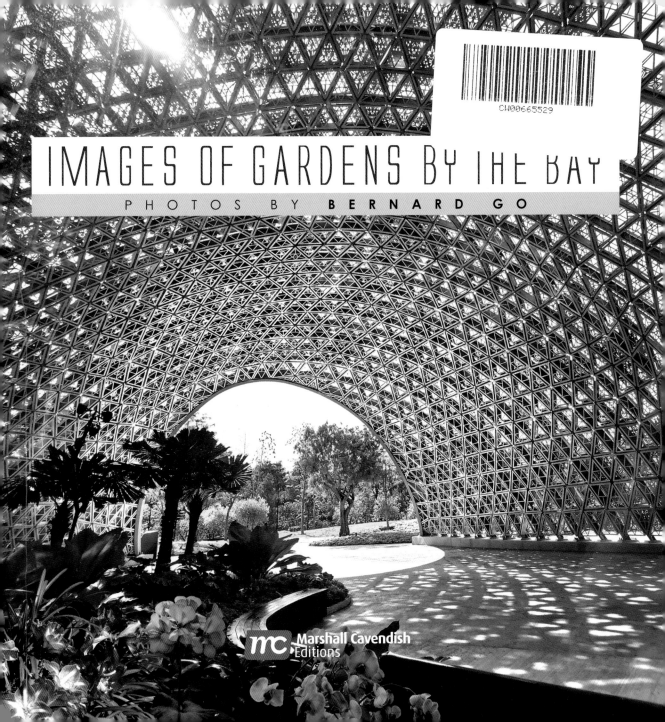

IMAGES OF GARDENS BY THE BAY

PHOTOS BY **BERNARD GO**

mc **Marshall Cavendish**
Editions

First published in 2015. Reprinted 2016, 2018 (twice), 2021

This edition published 2021 by Marshall Cavendish Editions
An imprint of Marshall Cavendish International

Series Editor: Melvin Neo
Design & Photographs: Bernard Go Kwang Meng
Images on pages 20–21 and 85 courtesy of Gardens by the Bay

A member of the
Times Publishing Group

Other Marshall Cavendish Offices:
Marshall Cavendish Corporation, 800 Westchester Ave, Suite N-641, Rye Brook, NY 10573, USA · Marshall Cavendish International (Thailand) Co Ltd, 253 Asoke, 16th Floor, Sukhumvit 21 Road, Klongtoey Nua, Wattana, Bangkok 10110, Thailand · Marshall Cavendish (Malaysia) Sdn Bhd, Times Subang, Lot 46, Subang Hi-Tech Industrial Park, Batu Tiga, 40000 Shah Alam, Selangor Darul Ehsan, Malaysia

Marshall Cavendish is a registered trademark of Times Publishing Limited

National Library Board, Singapore Cataloguing in Publication Data

Name(s): Go, Bernard Kwang Meng, photographer.
Title: Images of Gardens by the Bay / photos by Bernard Go.
Description: Singapore : Marshall Cavendish Editions, 2021. | First published: 2015.
Identifier(s): OCN 1151489112 | ISBN 978-981-4893-40-4 (paperback)
Subject(s): LCSH: Gardens—Singapore—Pictorial works. | Parks—Singapore—Pictorial works. | Gardens by the Bay (Singapore)—Pictorial works.
Classification: DDC 635.9095957—dc23

Printed in Singapore

Front Cover: View from the Supertree Observatory. Back Cover (from left to right):
Dance tableau at Floral Fantasy, a totem at The Canyon, Float tableau at Floral Fantasy.
Page 1: View of the SG50 Lattice.

IMAGES OF
GARDENS BY THE BAY

CONTENTS

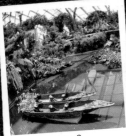

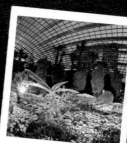

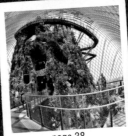

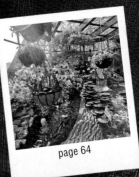

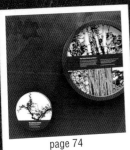

Heritage Gardens

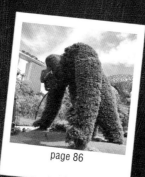

World Of Plants

Lakes & Islands

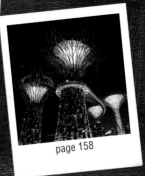

Supertree Grove

01

INTRODUCTION

Gardens by the Bay comprises three gardens: Bay South, Bay East and Bay Central. At present only the first phase, the 54-hectare Bay South is open. The largest of the three gardens, it forms a major space within Marina Bay and is linked to the iconic Marina Bay Sands by the Dragonfly Bridge.

BAY SOUTH GARDEN

Designed by UK-based landscape architecture firm Grant Associates, the Gardens showcase the best in tropical horticulture and garden artistry with a mass display of flowers and colourful foliage. Key features of the Bay South Garden are the Flower Dome and Cloud Forest conservatories, 18 Supertrees as well as themed gardens and lakes.

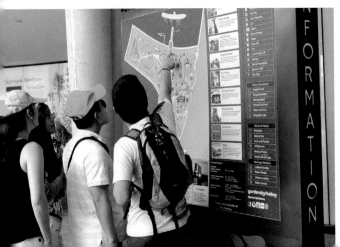

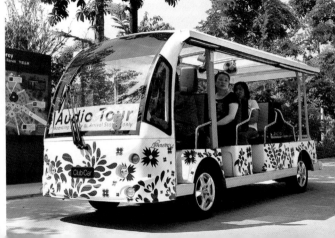

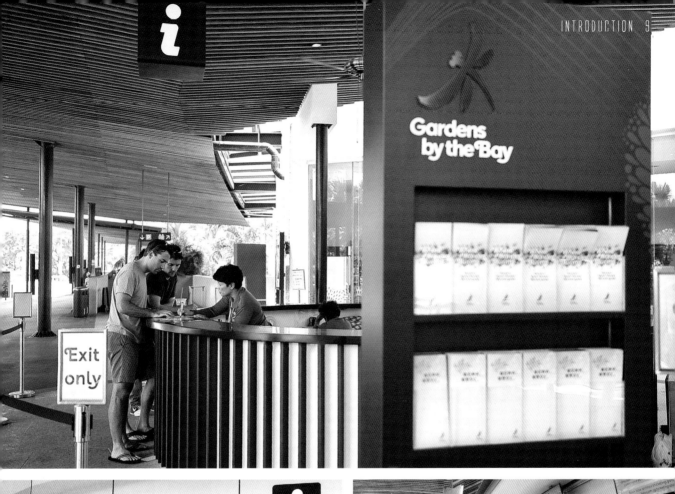

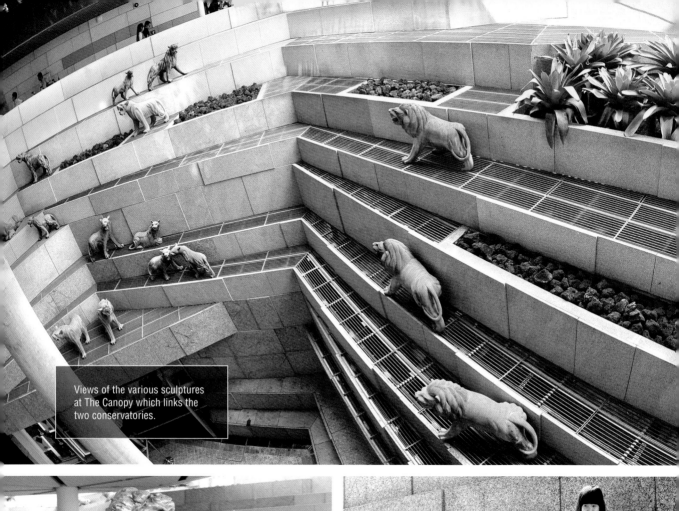

Views of the various sculptures at The Canopy which links the two conservatories.

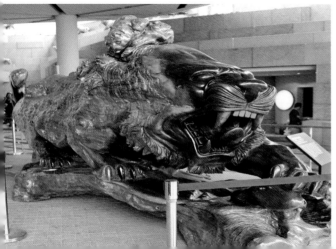
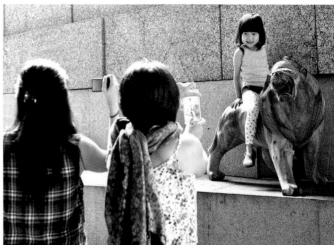

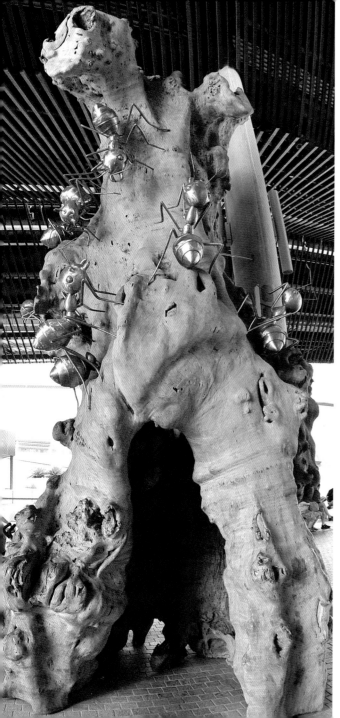
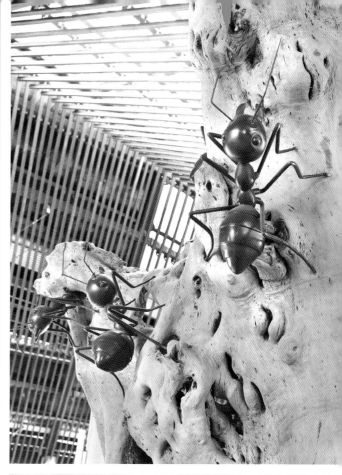
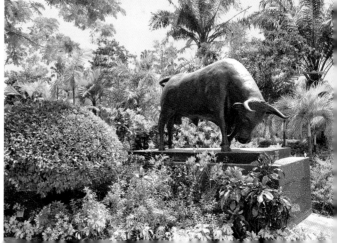

Specially designed tracks allow visitors and joggers to get up close to the iconic Cloud Forest and Flower Dome conservatories.

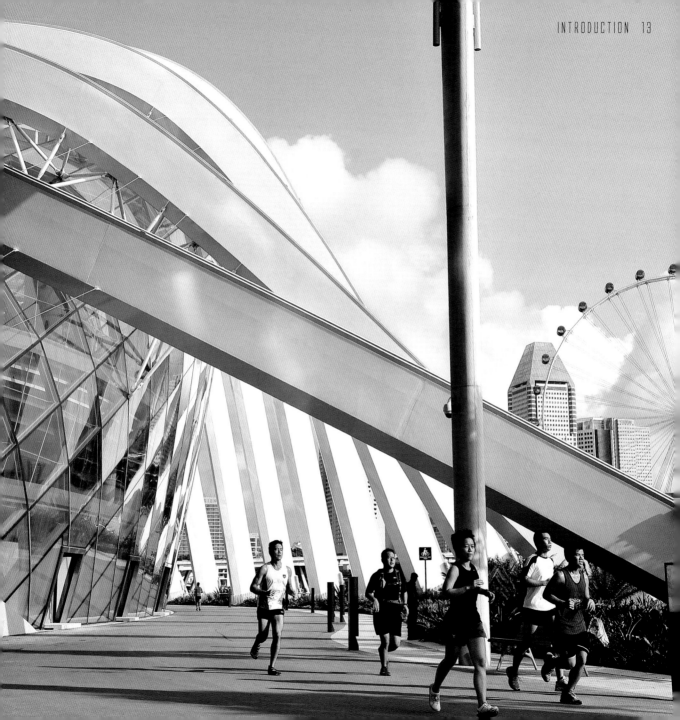

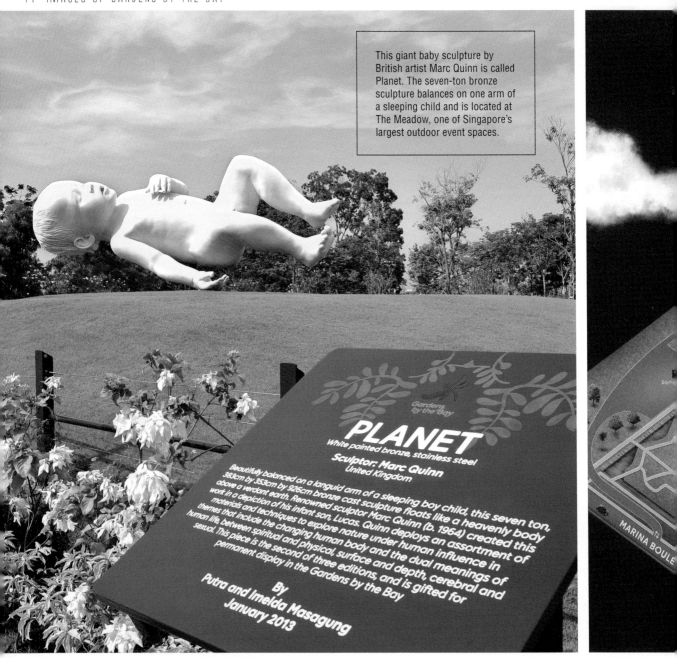

This giant baby sculpture by British artist Marc Quinn is called Planet. The seven-ton bronze sculpture balances on one arm of a sleeping child and is located at The Meadow, one of Singapore's largest outdoor event spaces.

Gardens by the Bay

PLANET
White painted bronze, stainless steel

Sculptor: Marc Quinn
United Kingdom

Beautifully balanced on a languid arm of a sleeping boy child, this seven ton, 383cm by 353cm by 926cm bronze cast sculpture floats like a heavenly body above a verdant earth. Renowned sculptor Marc Quinn (b. 1964) created this work in a depiction of his infant son, Lucas. Quinn deploys an assortment of materials and techniques to explore nature under human influence in themes that include the changing human body and the dual meanings of human life, between spiritual and physical, surface and depth, cerebral and sexual. This piece is the second of three editions, and is gifted for permanent display in the Gardens by the Bay

By
Putra and Imelda Masagung
January 2013

MARINA BOULE

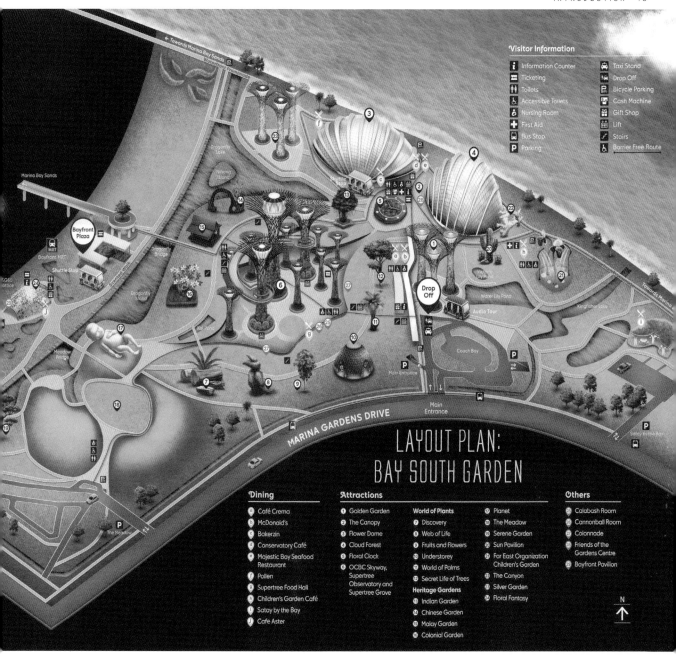

Visitor Information

i	Information Counter		Taxi Stand
	Ticketing		Drop Off
	Toilets		Bicycle Parking
	Accessible Toilets		Cash Machine
	Nursing Room		Gift Shop
	First Aid		Lift
	Bus Stop		Stairs
P	Parking		Barrier Free Route

← Towards Marina Bay Sands

Waterfront Promenade

Dragonfly Lake

Nirvana Island

Marina Bay Sands

Bayfront Plaza

MRT
Bayfront MRT

Shuttle Stop

Dragonfly Bridge

Dragonfly Island

SG50 Lattice

Koi Pond

Meadow Bridge

The Meadow

Shuttle Stop

Drop Off

Audio Tour

Water Lily Pond

Victoria Lily Pond

Kingfisher Lake

Towards Marina

Coach Bay

Main Entrance

Main Entrance

MARINA GARDENS DRIVE

Satay by the Bay

LAYOUT PLAN: BAY SOUTH GARDEN

Dining
- a. Café Crema
- b. McDonald's
- c. Bakerzin
- d. Conservatory Café
- e. Majestic Bay Seafood Restaurant
- f. Pollen
- g. Supertree Food Hall
- h. Children's Garden Café
- i. Satay by the Bay
- j. Cafe Aster

Attractions
- 1. Golden Garden
- 2. The Canopy
- 3. Flower Dome
- 4. Cloud Forest
- 5. Floral Clock
- 6. OCBC Skyway, Supertree Observatory and Supertree Grove

World of Plants
- 7. Discovery
- 8. Web of Life
- 9. Fruits and Flowers
- 10. Understorey
- 11. World of Palms
- 12. Secret Life of Trees

Heritage Gardens
- 13. Indian Garden
- 14. Chinese Garden
- 15. Malay Garden
- 16. Colonial Garden

- 17. Planet
- 18. The Meadow
- 19. Serene Garden
- 20. Sun Pavilion
- 21. Far East Organization Children's Garden
- 22. The Canyon
- 23. Silver Garden
- 24. Floral Fantasy

Others
- 25. Calabash Room
- 26. Cannonball Room
- 27. Colonnade
- 28. Friends of the Gardens Centre
- 29. Bayfront Pavilion

N ↑

02

FLOWER DOME

The Flower Dome replicates the cool-dry climate of the Mediterranean and the semi-arid subtropical regions of the world. Within this area are plants from the western part of South Africa, South West Australia, the coastal high plains of South America, the west coast of North America, and the Mediterranean Basin.

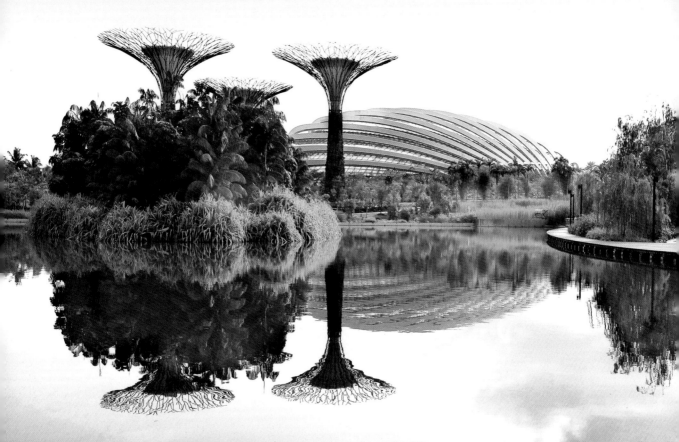

FLOWER DOME

There are nine different zones within the Flower Dome Conservatory: Baobabs, Succulent Garden, Australian Garden, South African Garden, South American Garden, Californian Garden, Mediterranean Garden, Olive Grove as well as the Flower Field. Over 87,000 plants comprising some 400 species and varieties can be found here. The temperature in the Flower Dome is kept between 23°C and 25°C and the relative humidity is between 60% and 80%.

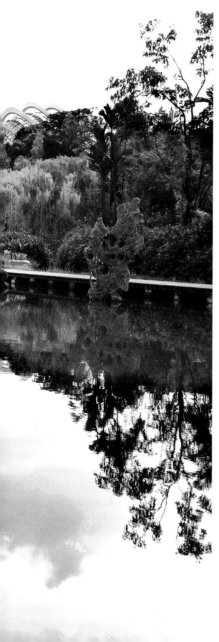

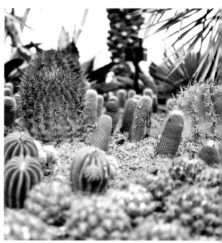

Cacti and other flowering plants are among the specially selected species found in the Flower Dome.

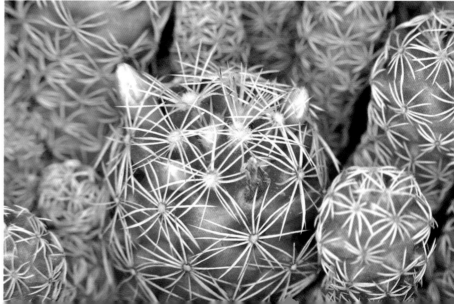

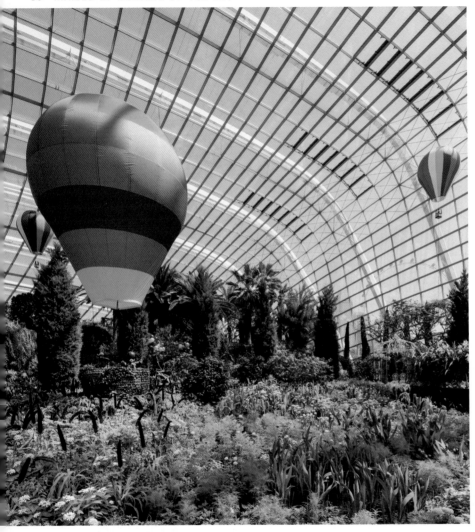

FLOWER FIELD

The Flower Field plays host to changing displays to reflect different seasons, festivals and themes. These plant displays are important as they show how plants adapt to cool-dry environments and also raise awareness of how many plant species face the threats of climate change and habitat loss brought about by human activities.

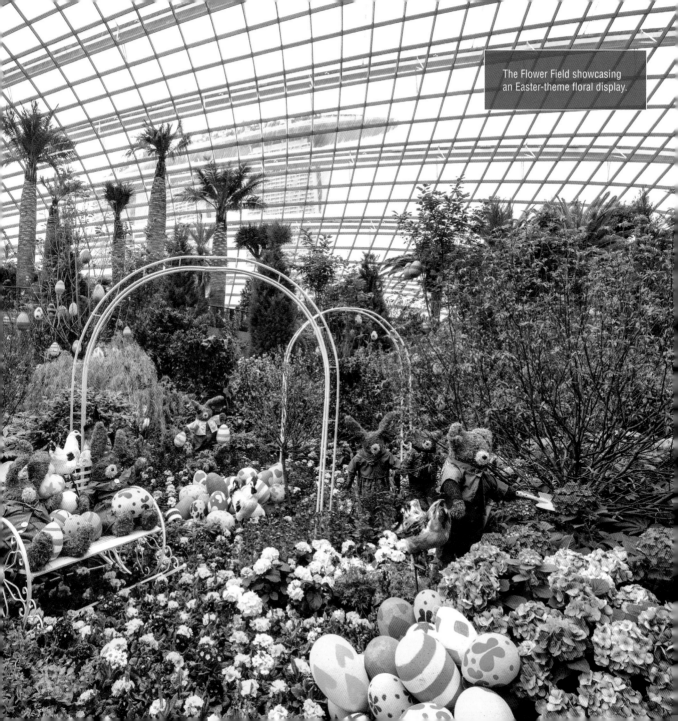

The Flower Field showcasing an Easter-theme floral display.

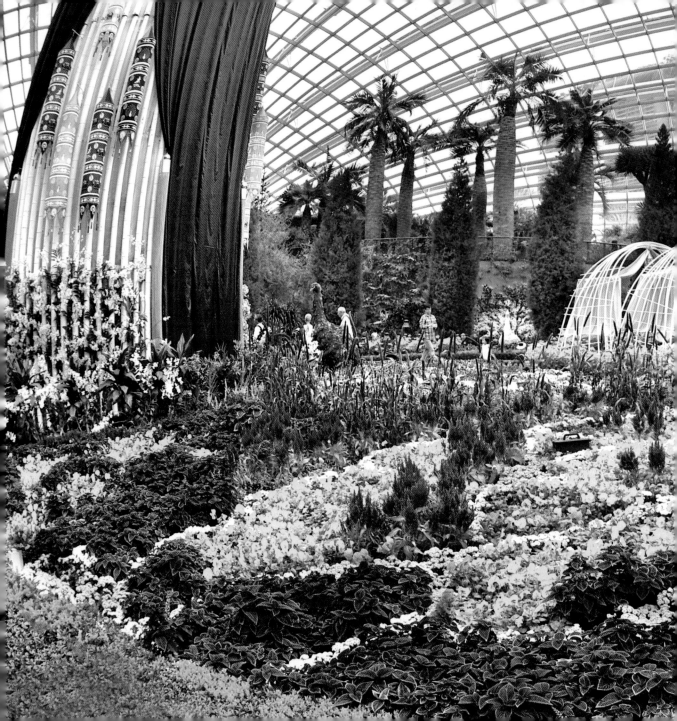

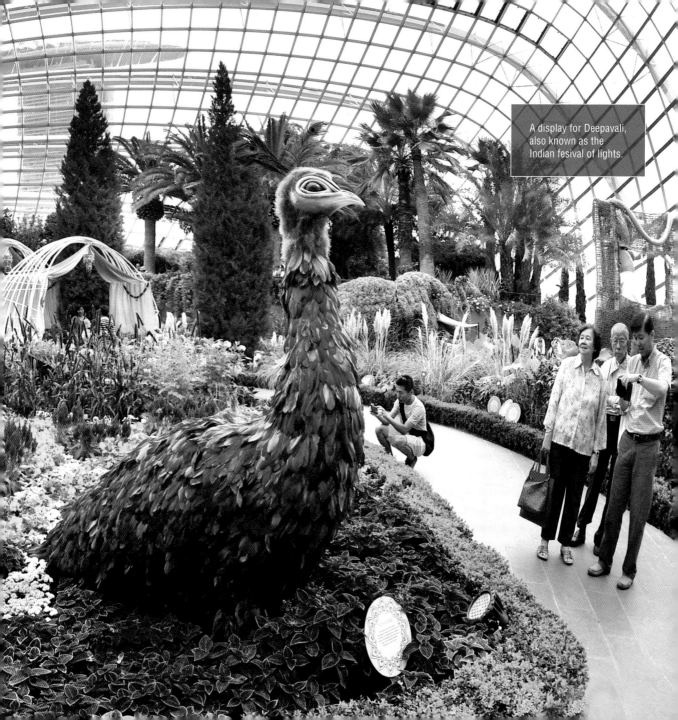

A display for Deepavali, also known as the Indian fesival of lights.

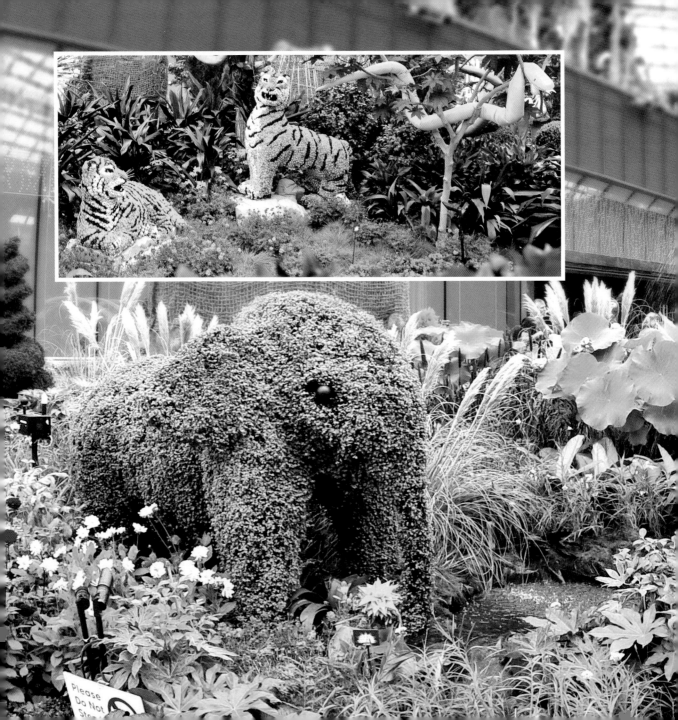

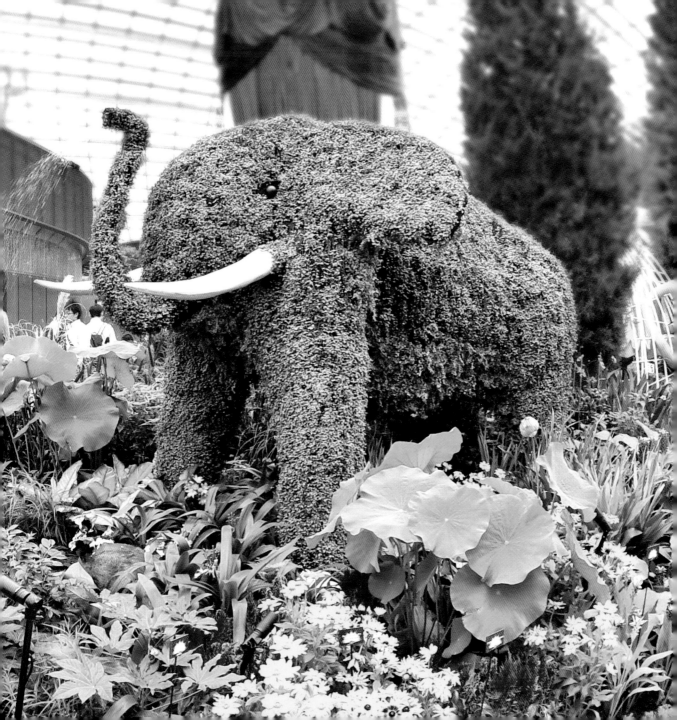

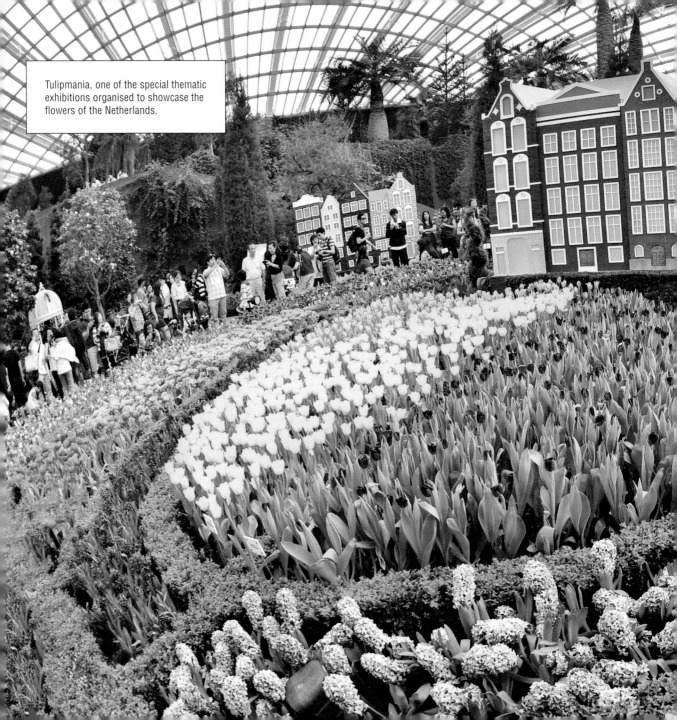

Tulipmania, one of the special thematic exhibitions organised to showcase the flowers of the Netherlands.

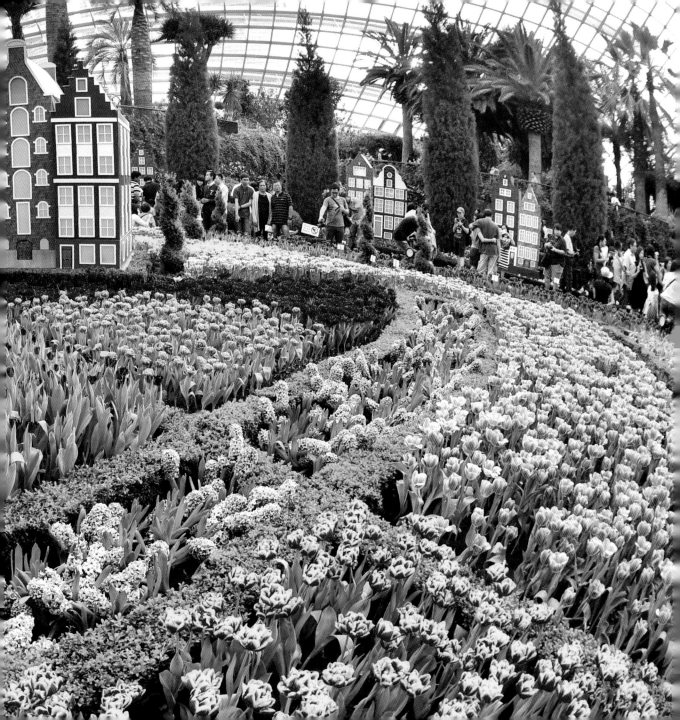

The dome is made up of 3,332 glass panels in 42 varying shapes and sizes. The panels allow light to enter the Flower Dome during the day and let visitors see the sky in the evening.

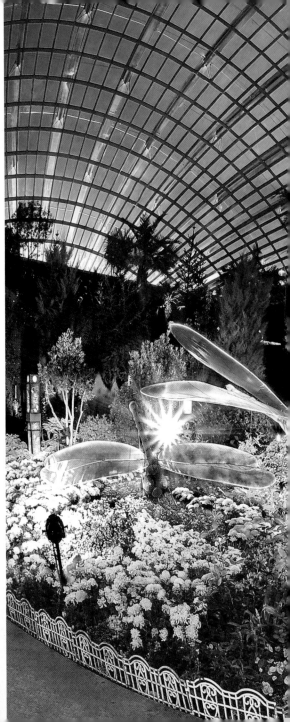

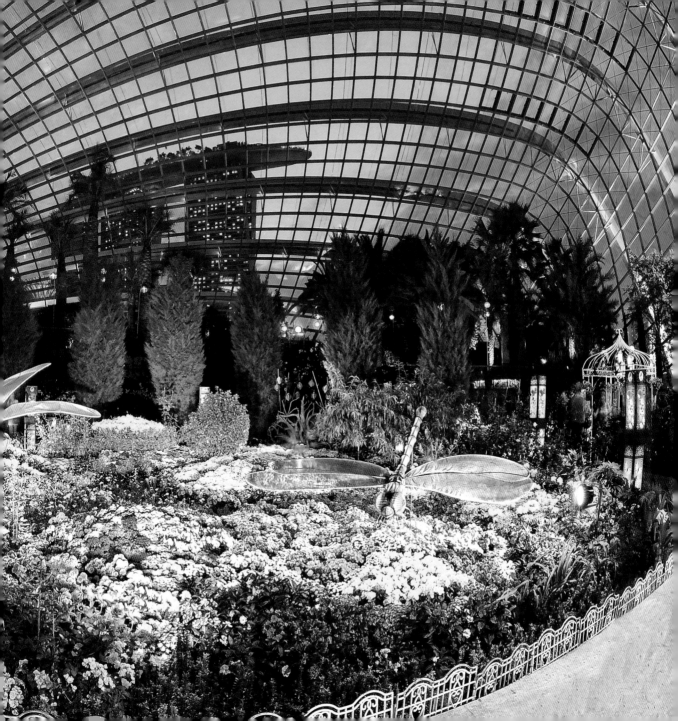

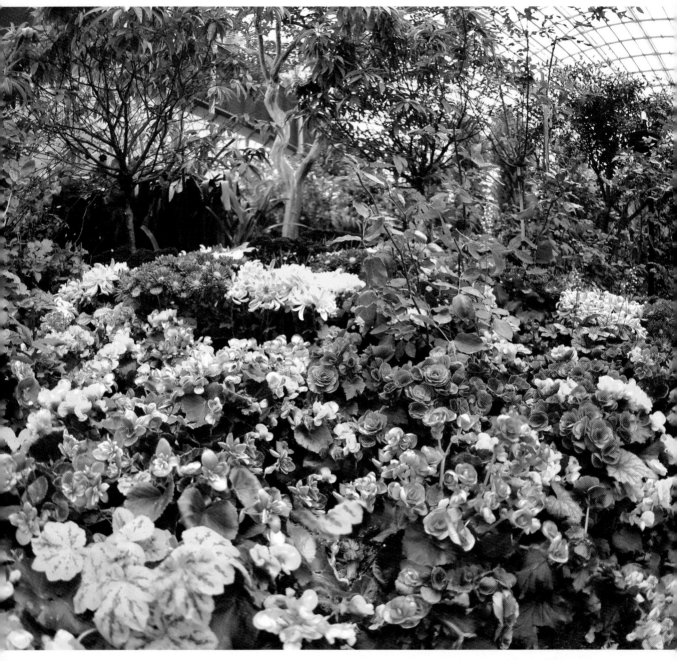

Bushfires

Fire is a frequent occurrence and an essential factor for certain plant communities in the Mediterranean climate zones of Australia.

Adaptations that enable the plants to survive include fire-resistant bark and lignotubers that develop into shoots after fire.

Seven species of Grass Tree (Xanthorrhoea spp.) are often cleared from fires, owing to the confirm that it flowers more profusely once it has burnt. When it is sold in plant nurseries, the old leaves are burned off with a blowtorch to give the plant its next appearance and to activate its bloom.

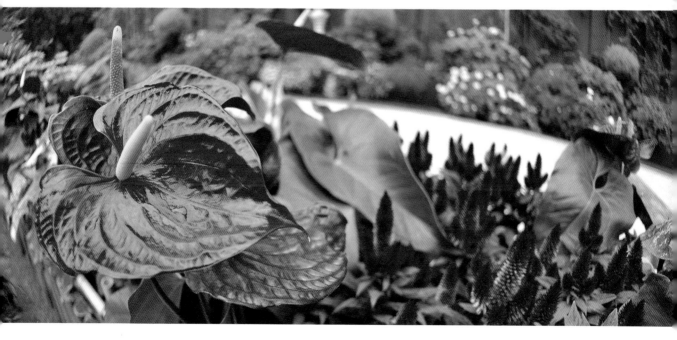

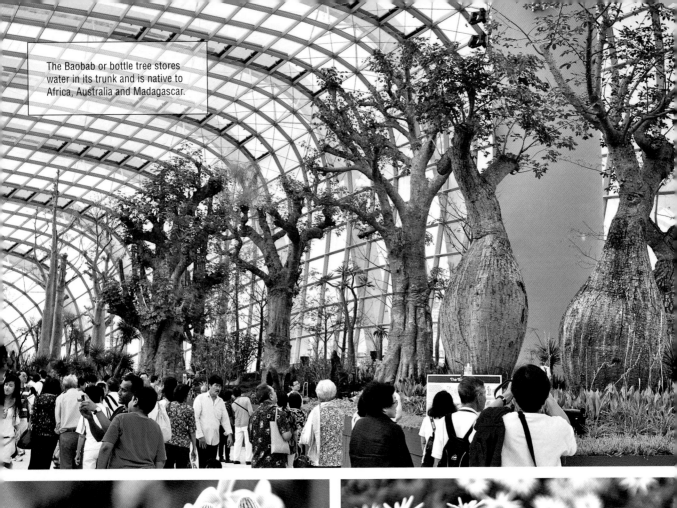

The Baobab or bottle tree stores water in its trunk and is native to Africa, Australia and Madagascar.

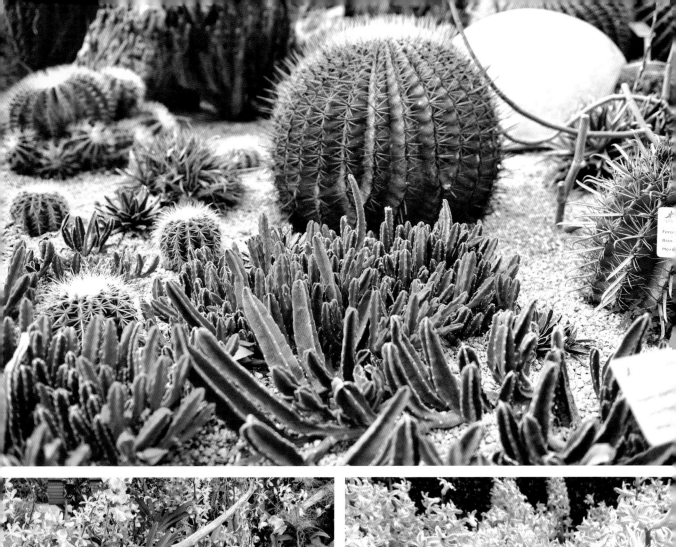
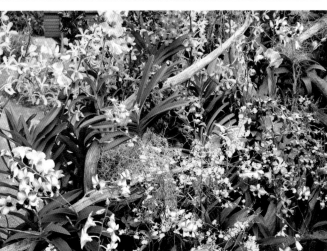
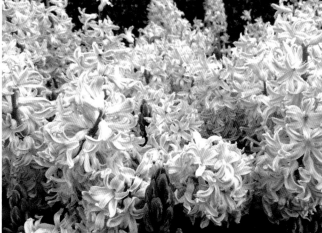

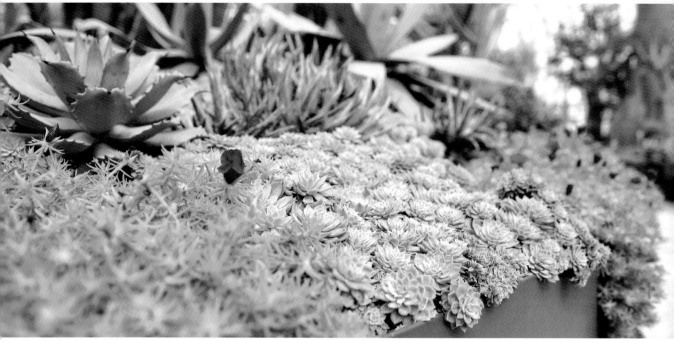

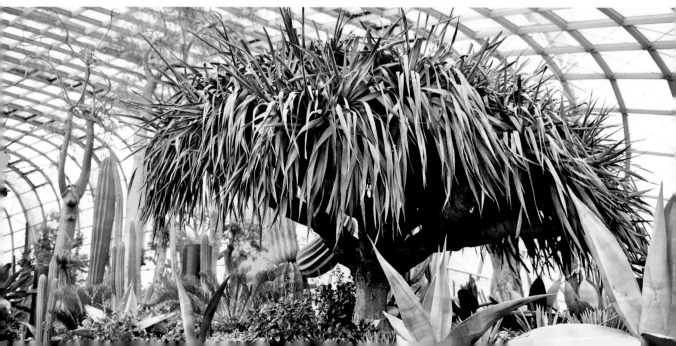

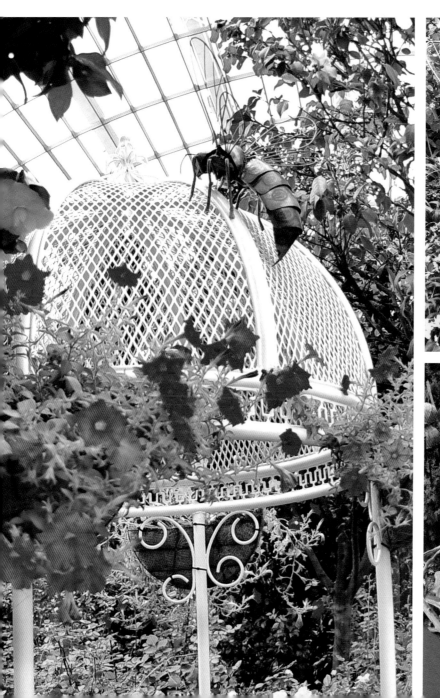
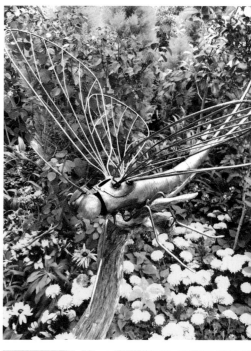

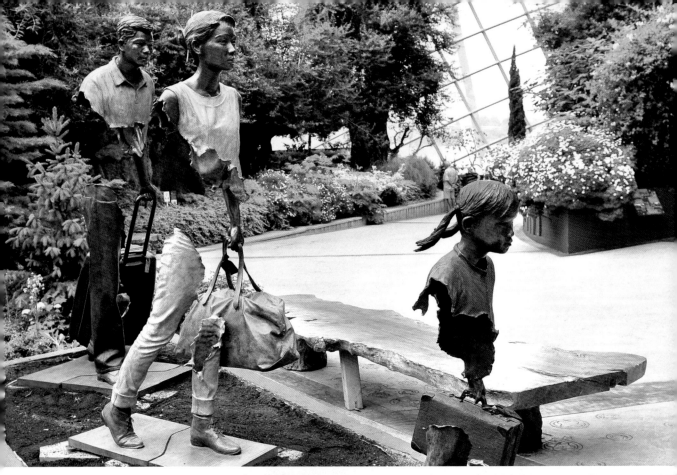

Assorted sculptures in the shape of animals, reptiles and other icons are found among the plants. These depict the plant's natural habitat or give a sense of the cultural significance of the particular display.

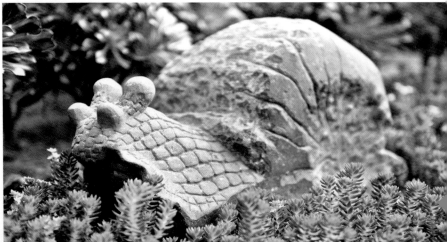

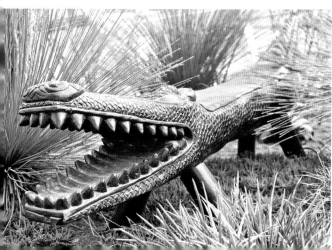
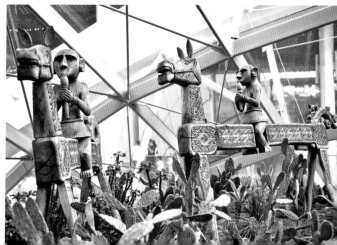

03

CLOUD FOREST

The Cloud Forest is designed to simulate the cool-moist climate of Tropical Montane regions which are areas located between 1,000 and 3,500 metres above sea level such as Mt Kinabalu (Sabah, Malaysia) and higher elevation areas in South America and Africa.

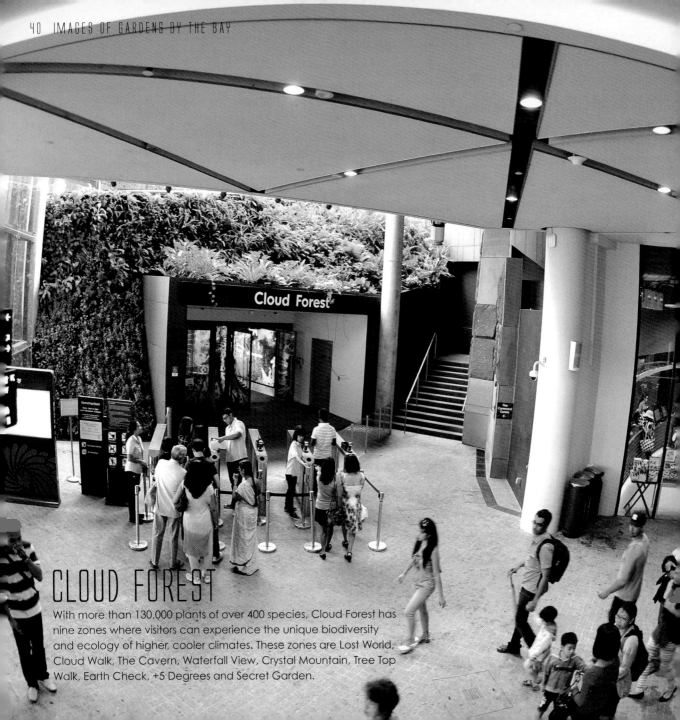

CLOUD FOREST

With more than 130,000 plants of over 400 species, Cloud Forest has nine zones where visitors can experience the unique biodiversity and ecology of higher, cooler climates. These zones are Lost World, Cloud Walk, The Cavern, Waterfall View, Crystal Mountain, Tree Top Walk, Earth Check, +5 Degrees and Secret Garden.

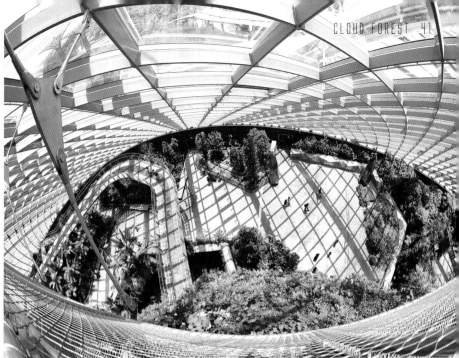

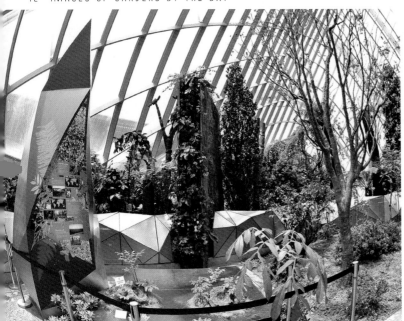

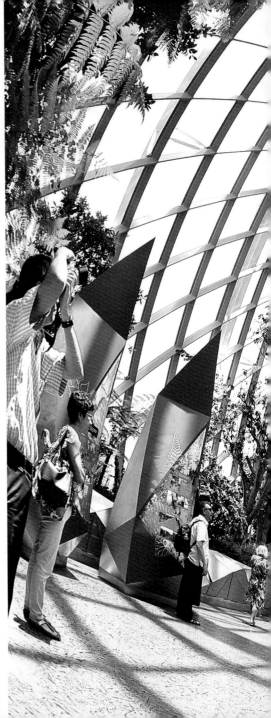

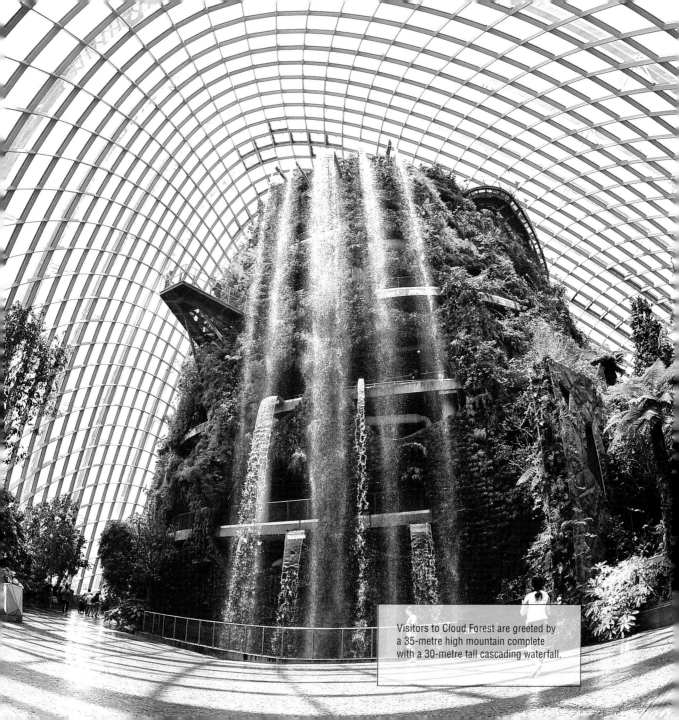

Visitors to Cloud Forest are greeted by
a 35-metre high mountain complete
with a 30-metre tall cascading waterfall.

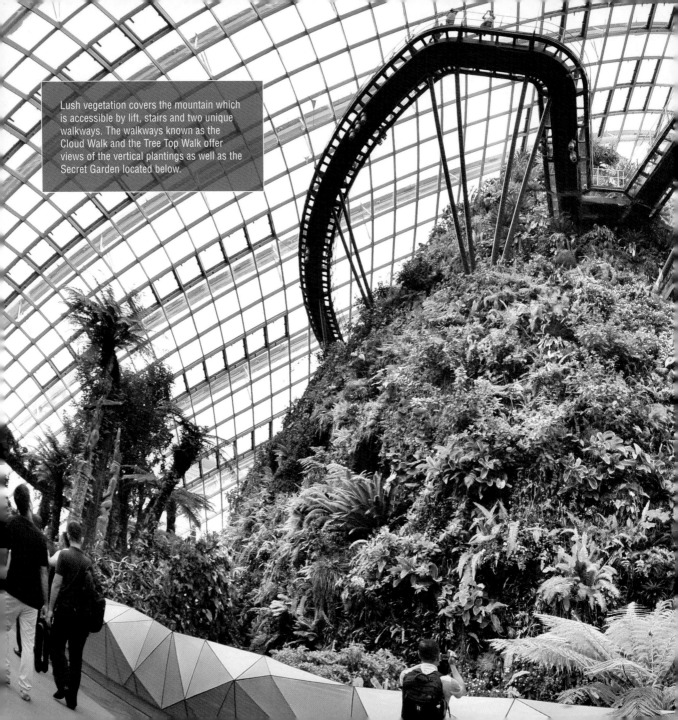

Lush vegetation covers the mountain which is accessible by lift, stairs and two unique walkways. The walkways known as the Cloud Walk and the Tree Top Walk offer views of the vertical plantings as well as the Secret Garden located below.

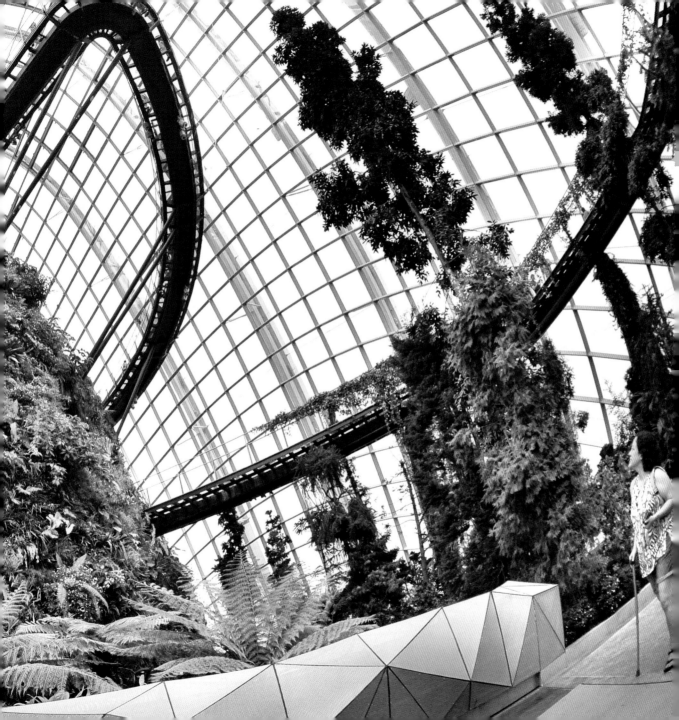

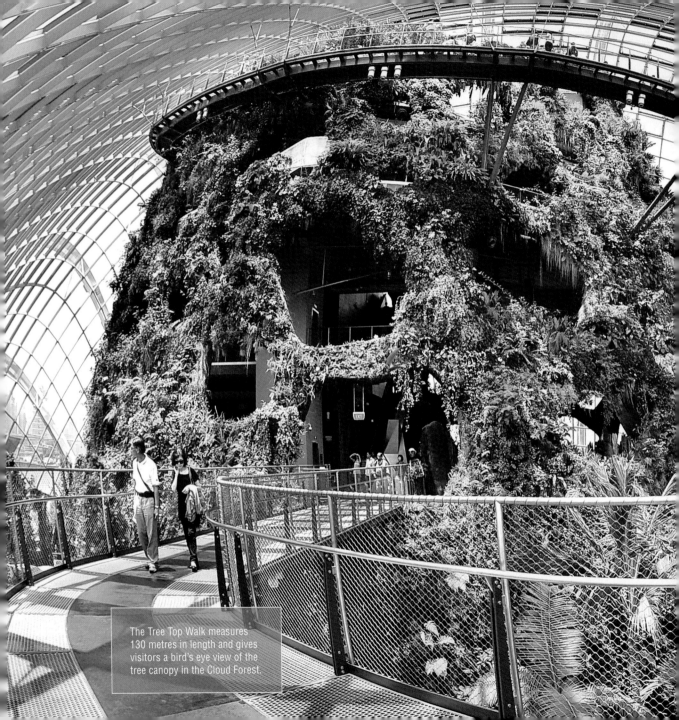

The Tree Top Walk measures
130 metres in length and gives
visitors a bird's eye view of the
tree canopy in the Cloud Forest.

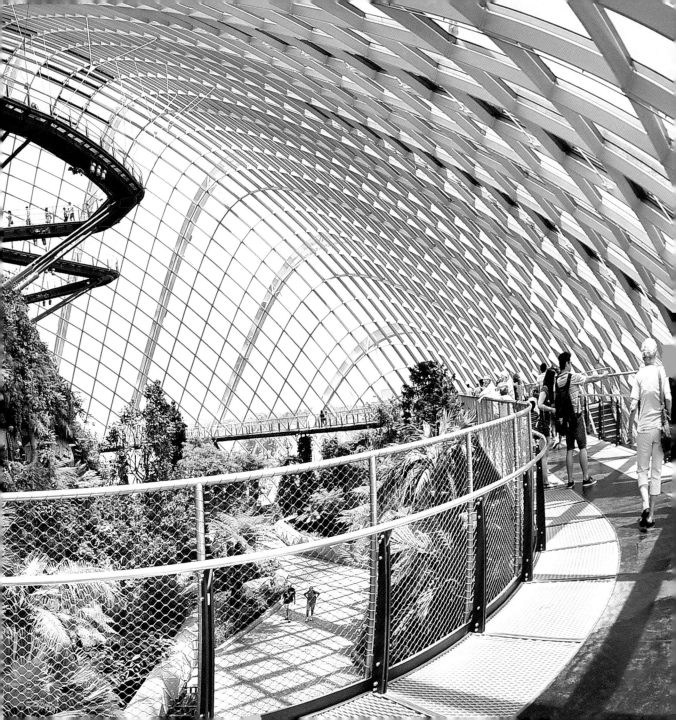

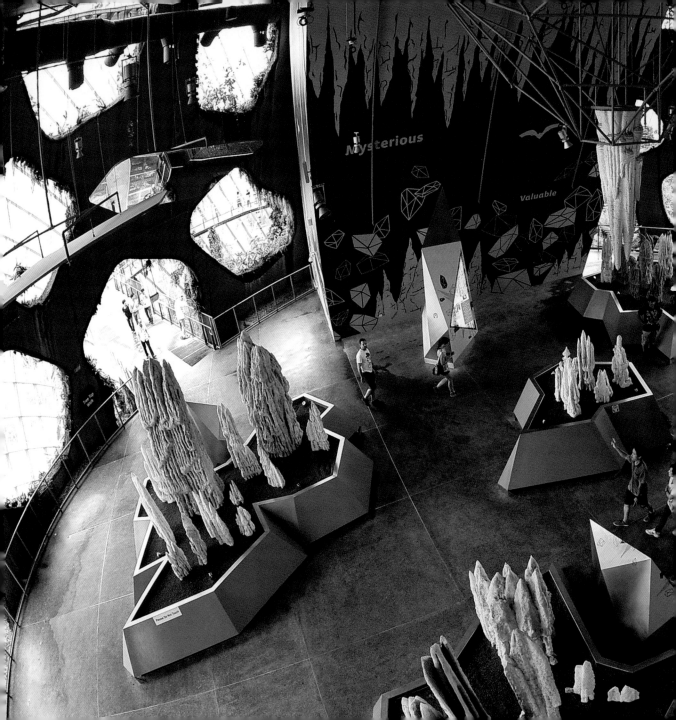

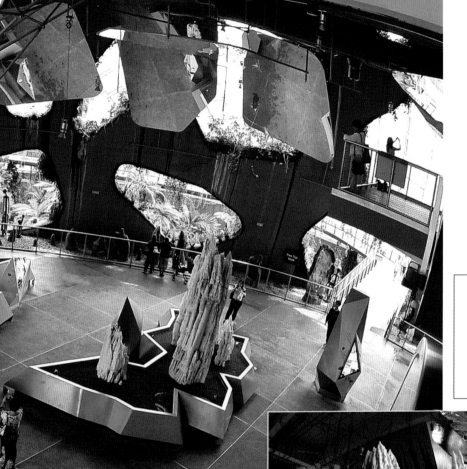

This zone known as Crystal Mountain is found in a simulated cavern. Visitors can learn about geology and see how stalactites and stalagmites are formed. They can also find out more about the formation of the continents and the Earth.

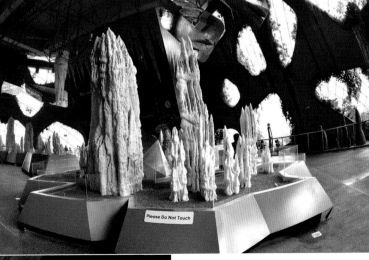

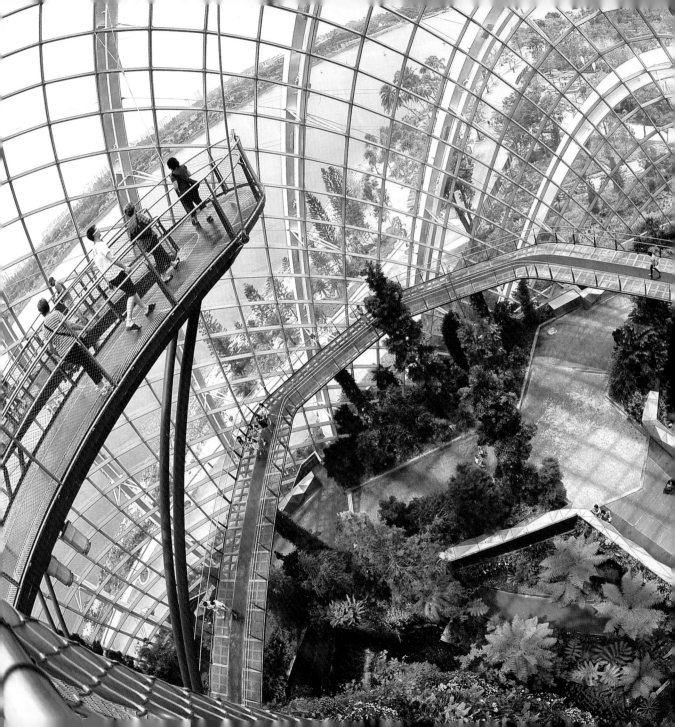

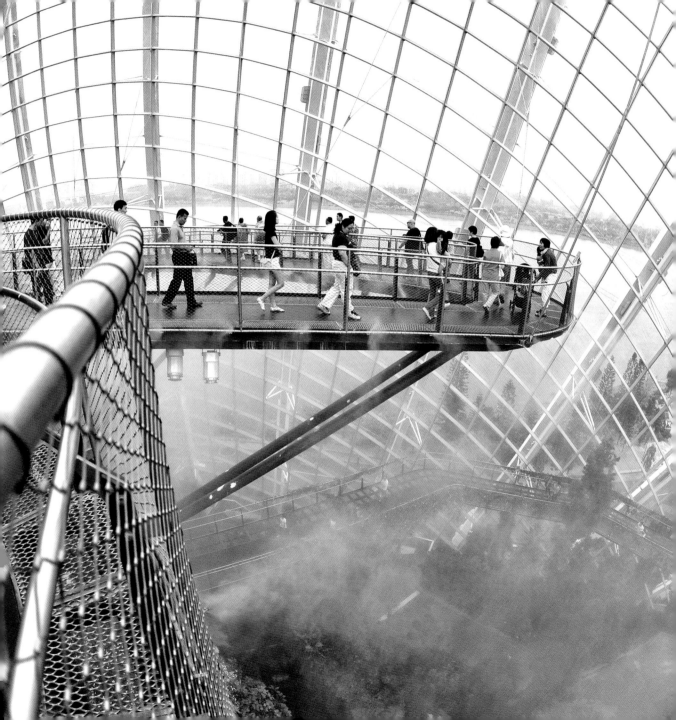

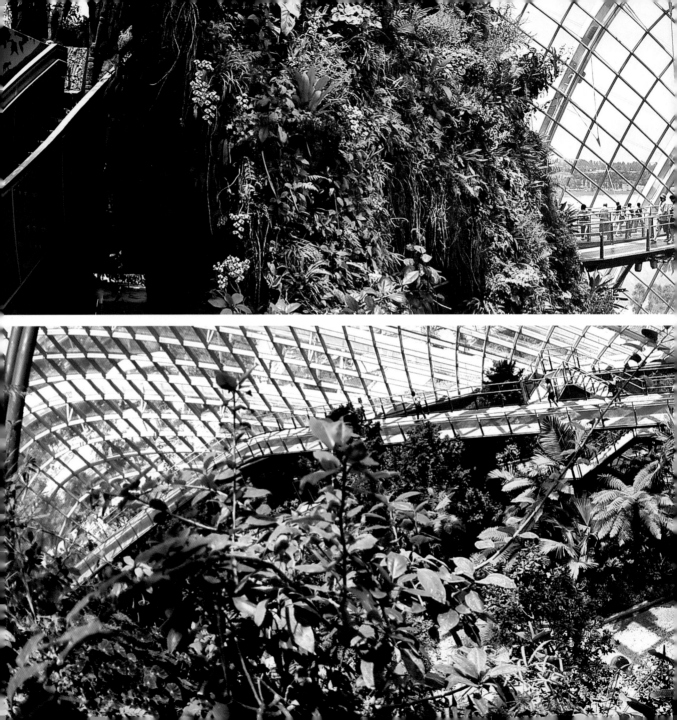

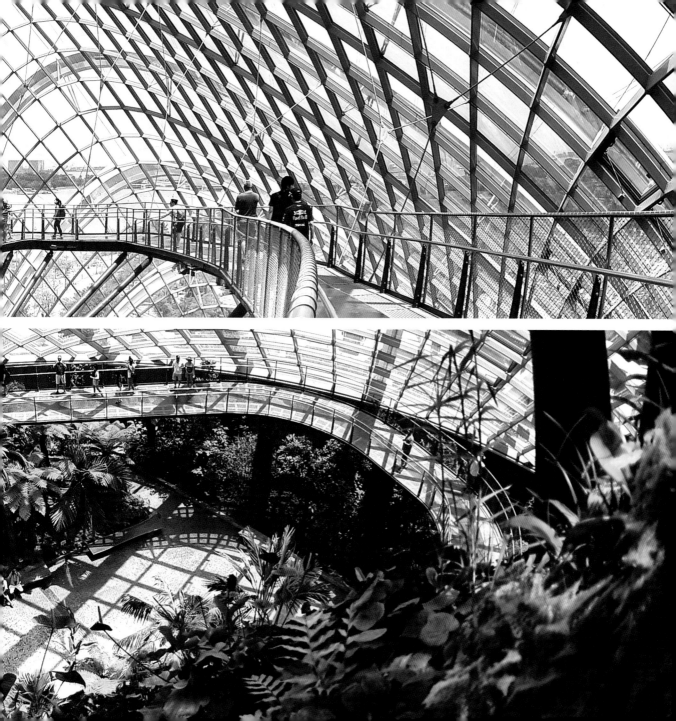

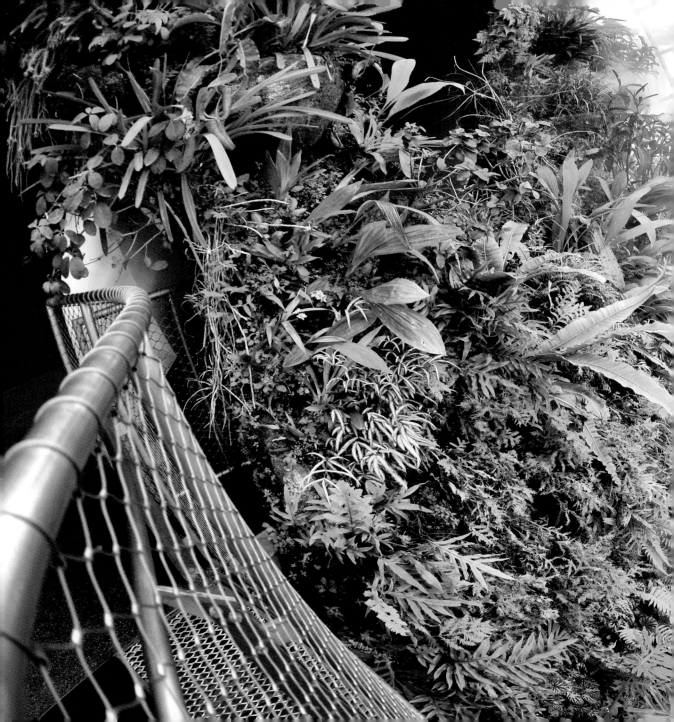

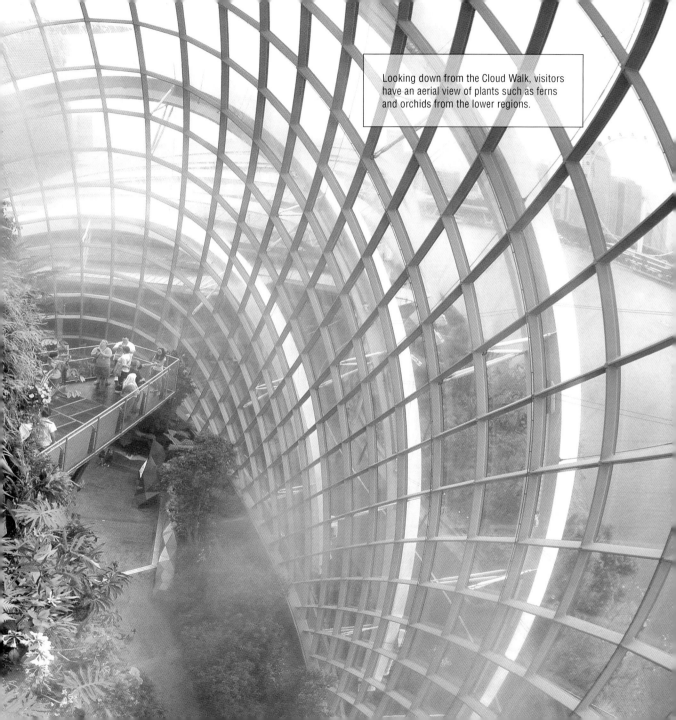

Looking down from the Cloud Walk, visitors have an aerial view of plants such as ferns and orchids from the lower regions.

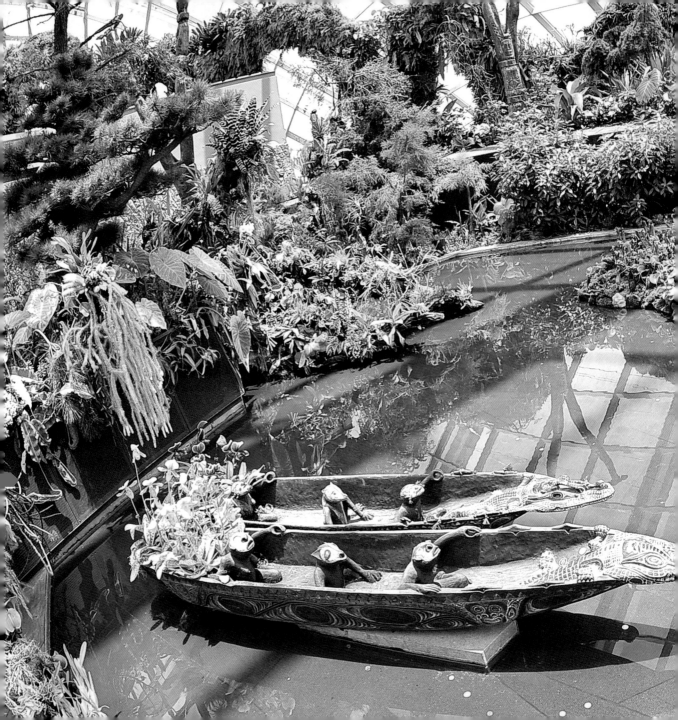

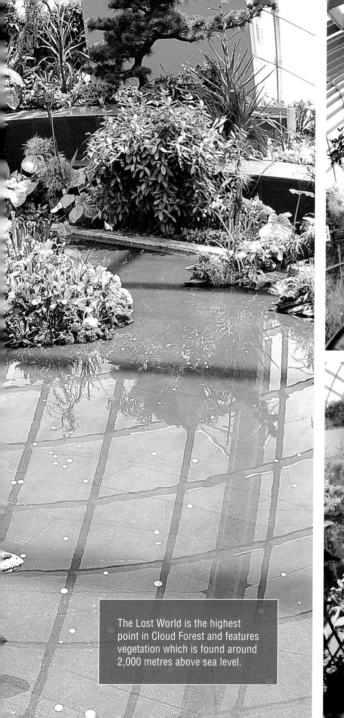
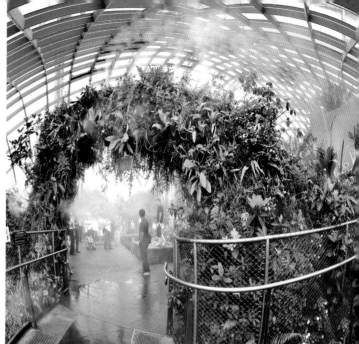
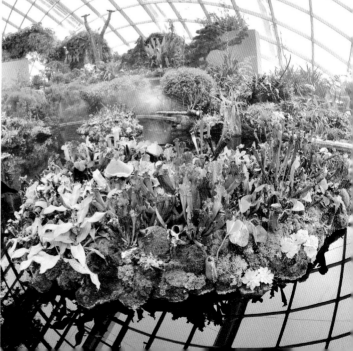

The Lost World is the highest point in Cloud Forest and features vegetation which is found around 2,000 metres above sea level.

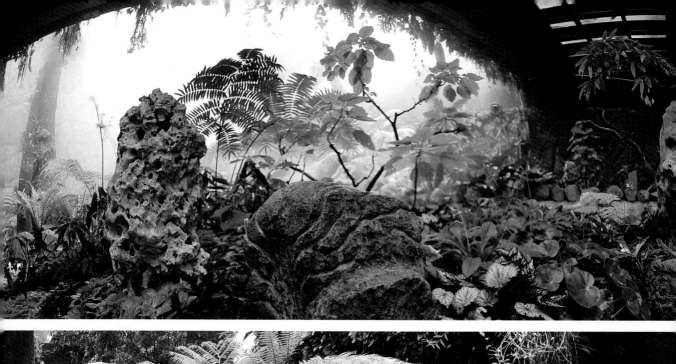
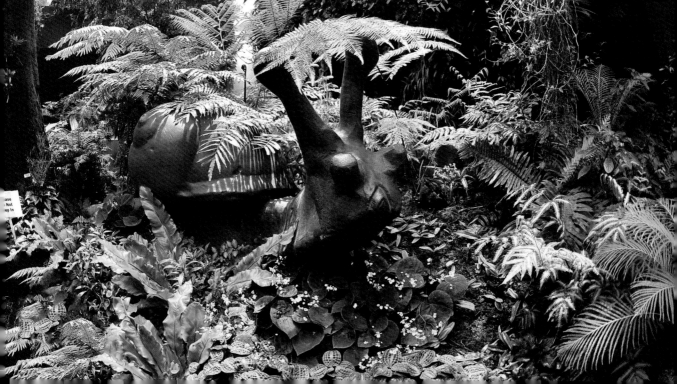

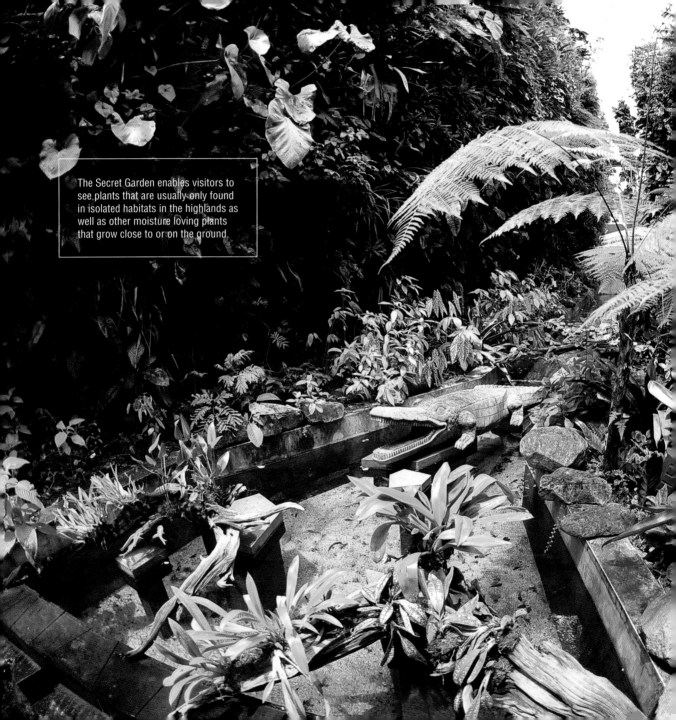

The Secret Garden enables visitors to
see plants that are usually only found
in isolated habitats in the highlands as
well as other moisture loving plants
that grow close to or on the ground.

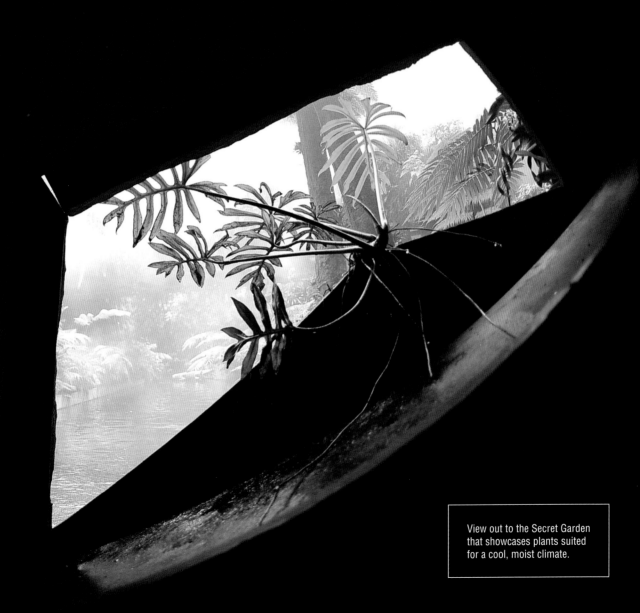

View out to the Secret Garden that showcases plants suited for a cool, moist climate.

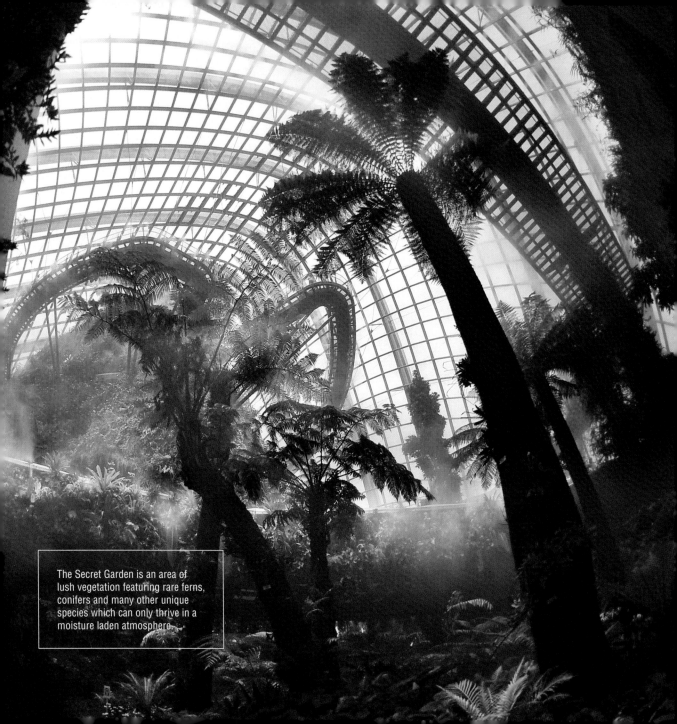

The Secret Garden is an area of
lush vegetation featuring rare ferns,
conifers and many other unique
species which can only thrive in a
moisture laden atmosphere.

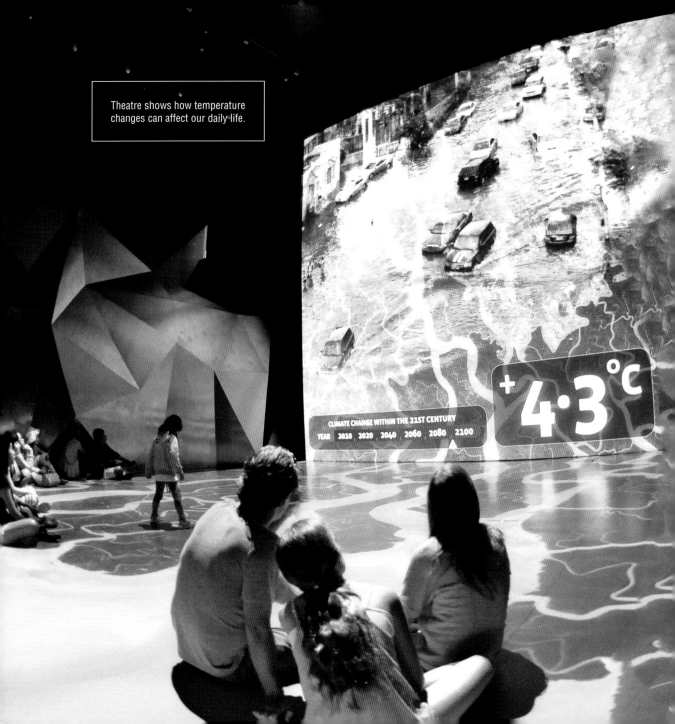

Theatre shows how temperature changes can affect our daily life.

CLIMATE CHANGE WITHIN THE 21ST CENTURY

YEAR 2010 2020 2040 2060 2080 2100

+4·3°C

04

This conservatory measuring 1,500 square metres showcases more than 3,000 plants from more than 150 species.

FLORAL FANTASY

FLORAL FANTASY

In this attraction, flowers, artistry and technology come together to create a dream-like, fantastical experience for visitors. It comprises four diverse garden landscapes: Dance, Float, Waltz and Drift, each showcasing a different concept, as well as a 4D ride called Flight of the Dragonfly.

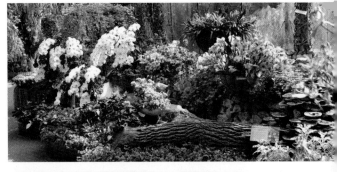

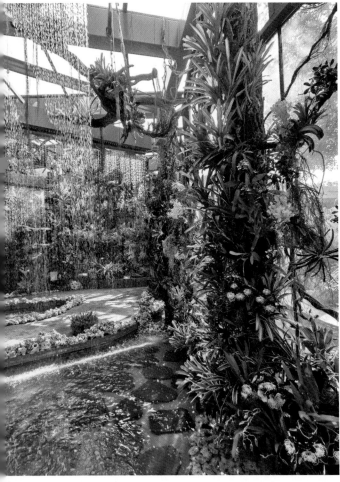

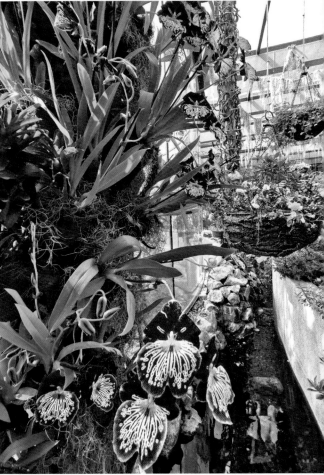

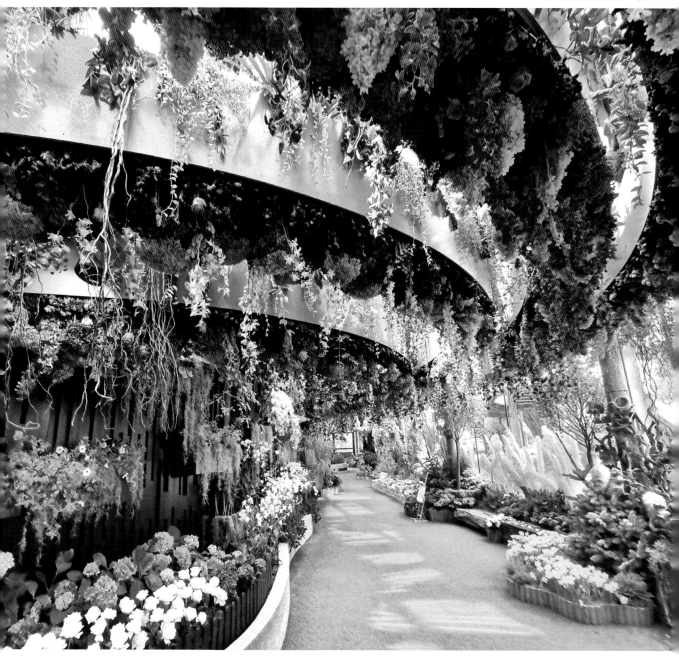

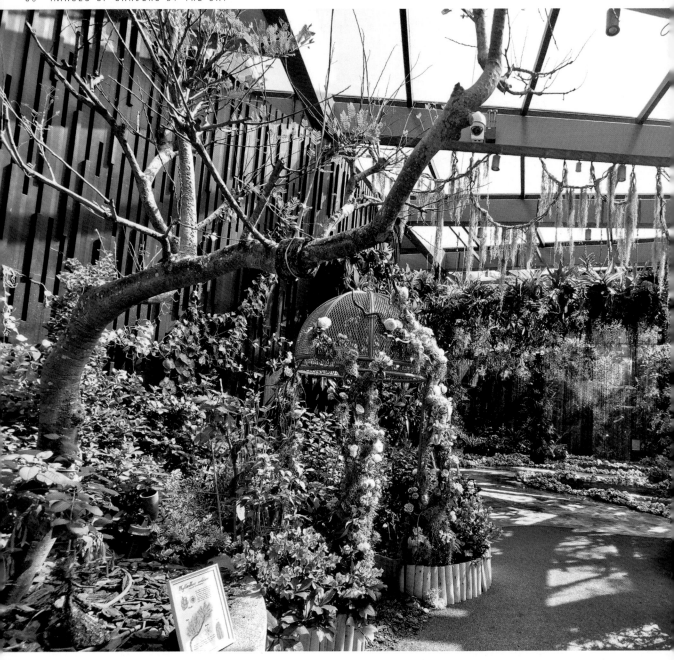

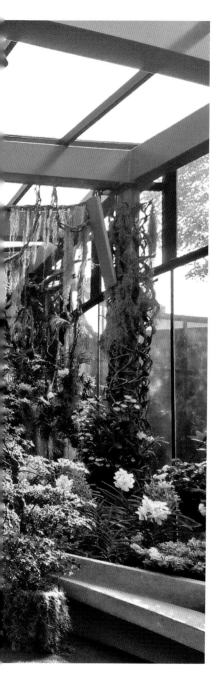

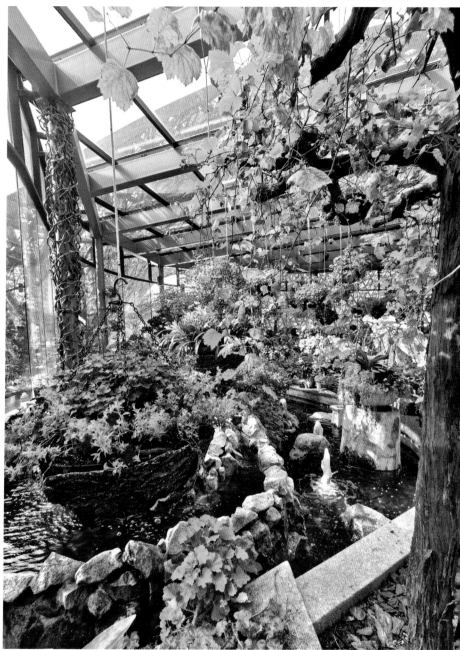

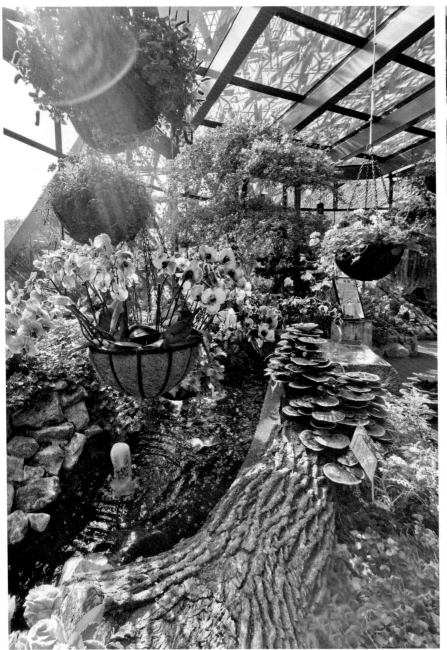
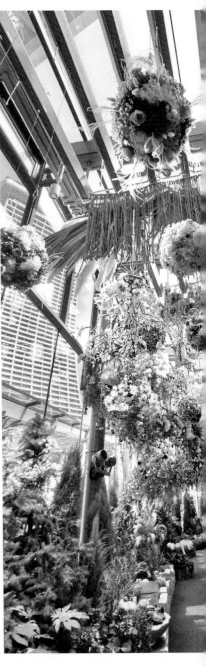

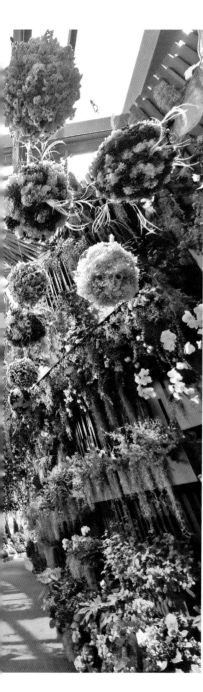

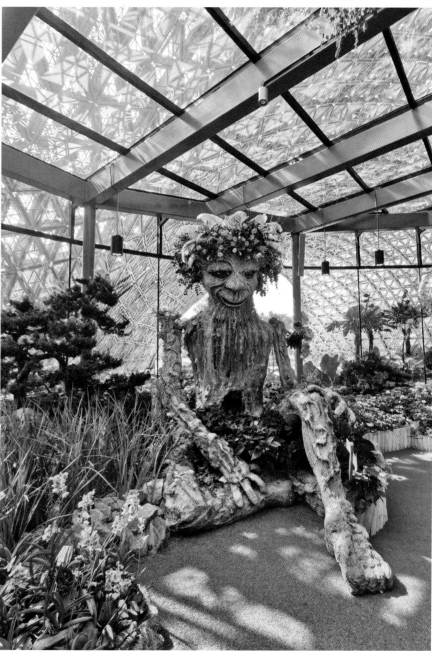

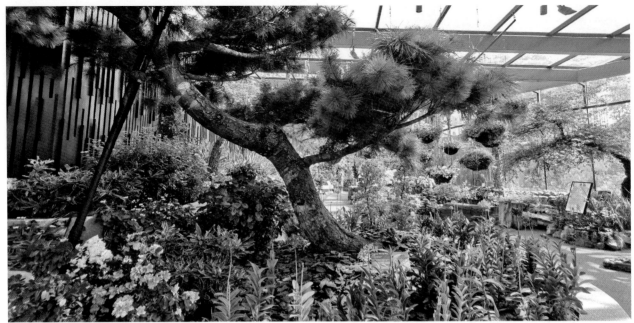

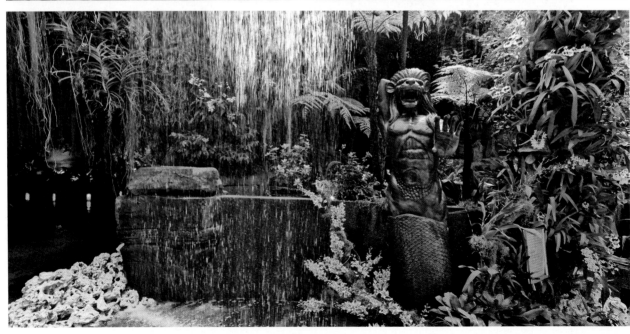

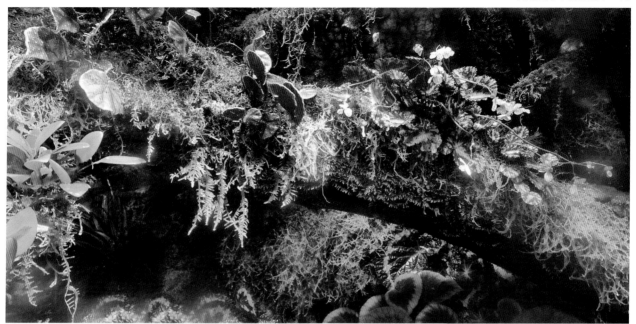

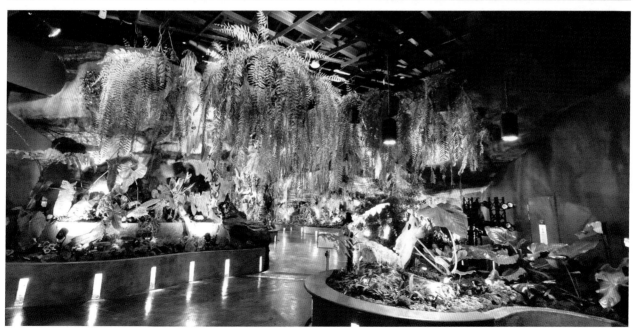

05

Four specially-designed Heritage Gardens capture the essence and culture of the main ethnic groups in Singapore. Discover how each community uses indigenous plants in their daily lives and trace the country's development with the growth of the spice trade and export of local flora to the West.

HERITAGE GARDENS

INDIAN GARDEN

The *kolam* or Indian floral floor art is the inspiration for the design of this garden. The floral-shaped garden features plants such as the Tamarind whose fruit are used in Indian dishes and sweets. Other elements from Indian folklore and mythology reinforce the design theme.

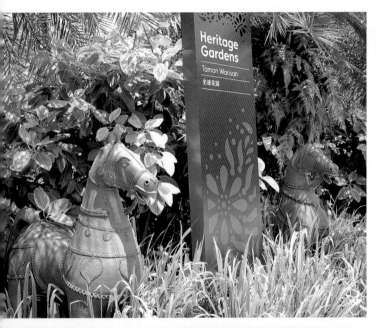

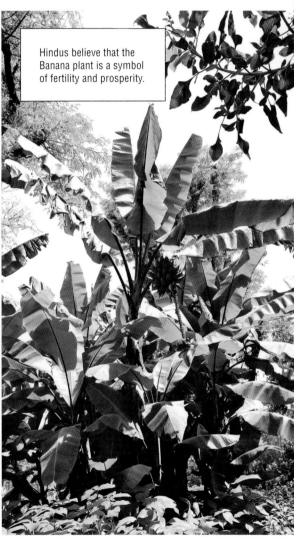

Hindus believe that the Banana plant is a symbol of fertility and prosperity.

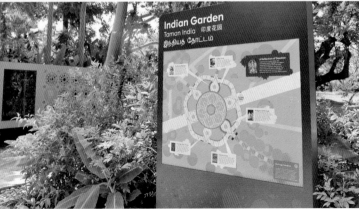

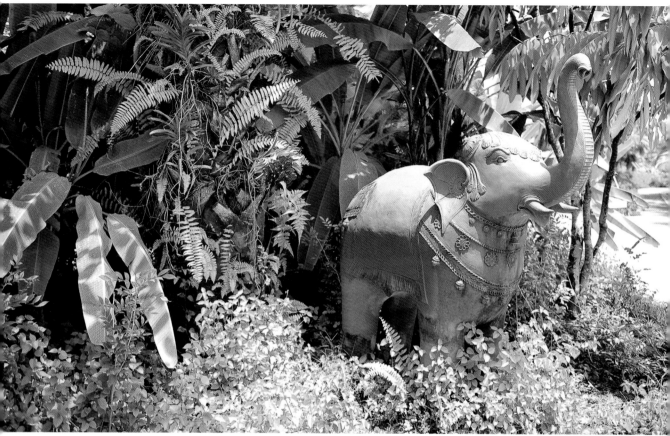

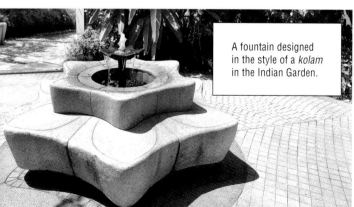

A fountain designed in the style of a *kolam* in the Indian Garden.

Information panels provide explanations on the plants used in Indian cuisine and in Ayurveda, a form of traditional medicine.

CHINESE GARDEN

Based on the theme "A Reflection of Literature", the Chinese Garden showcases Chinese literary motifs as well as pays tribute to its scholars and poets.

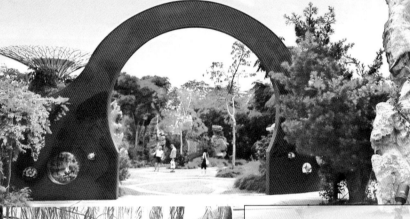

The moon gate marks the formal entrance to the walled garden. Plants such as the Bamboo, Pine and Plum take prominence alongside rock carvings and sculptures.

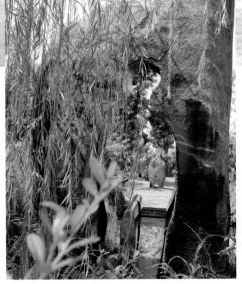

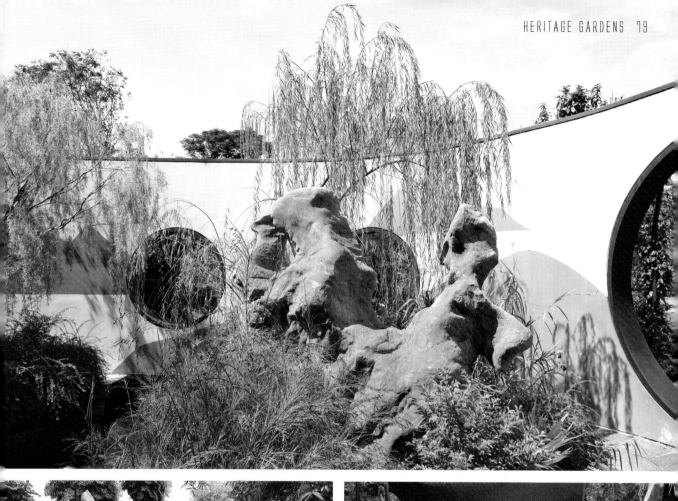

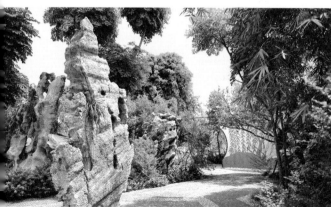

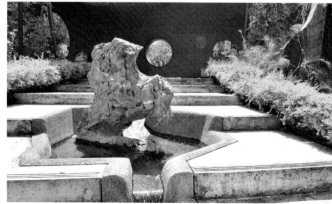

Wall panels provide descriptions of the plants while benches in the shaded pavilions let visitors enjoy views of this heritage garden.

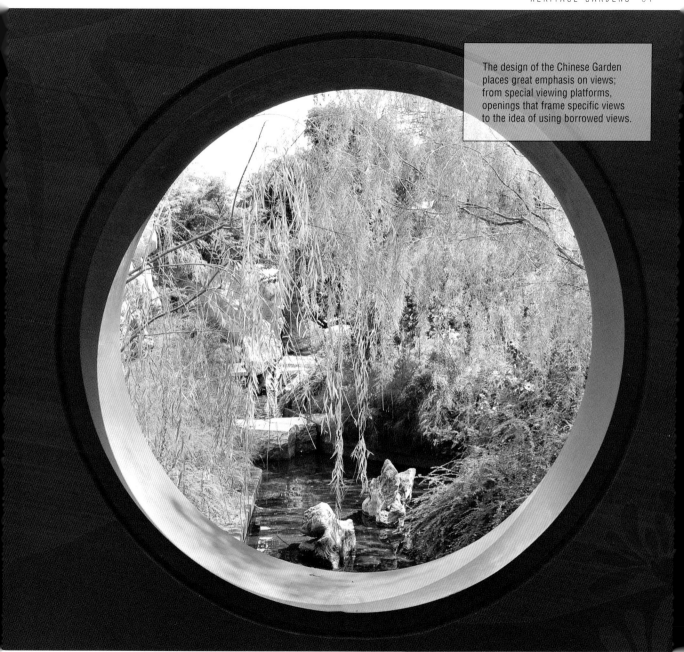

The design of the Chinese Garden places great emphasis on views; from special viewing platforms, openings that frame specific views to the idea of using borrowed views.

MALAY GARDEN

The focus of the Malay Garden is a traditional timber house that actually functions as an information counter. Visitors can learn about Malay *kampongs* (villages), the plants grown in the ancient Royal Gardens as well as local place names named after plants.

Edible plants such as the Banana, Jambu, Pandan, Rambutan and Coconut, and fragrant ones such as the Hibiscus and Lantana are among the species found here.

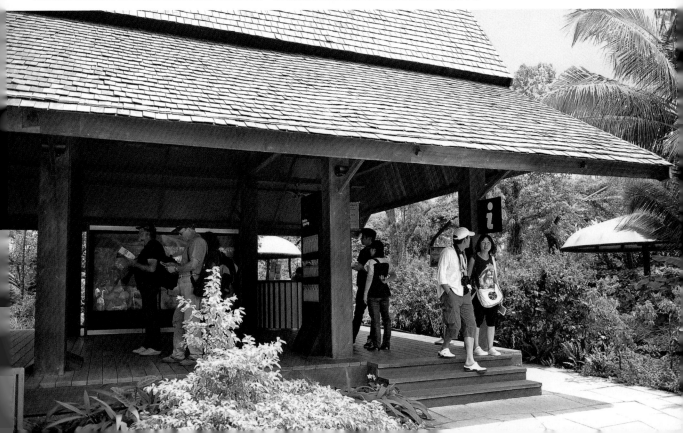

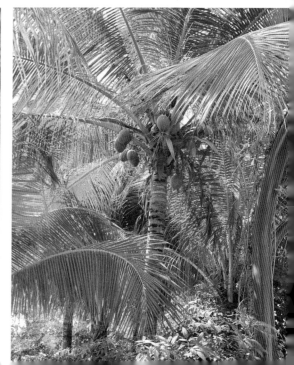

COLONIAL GARDEN

The Colonial Garden tells of the early days when Singapore was a British colony. Spices and other cash crops were grown in this region and exported "home" where there was demand for them. Selling these crops helped stimulate the economy and generated a fair amount of revenue.

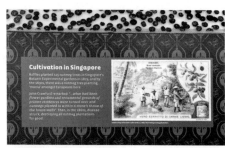

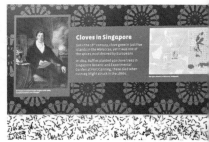

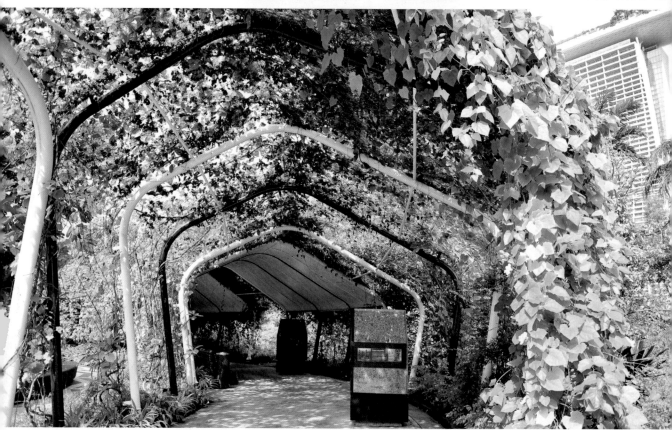

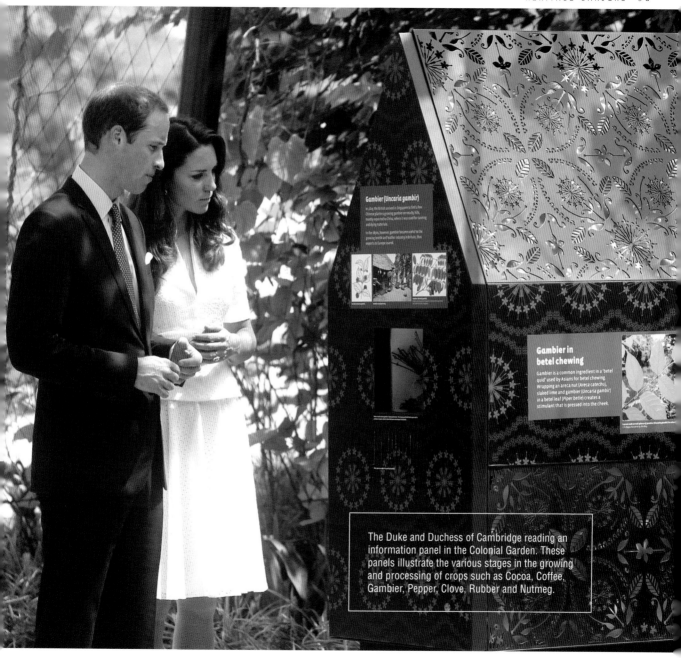

Gambier (Uncaria gambir)

In 1819, the British arrived in Singapore to find a few Chinese planters growing gambier on nearby hills, mostly exported to China, where it was used for tanning and dyeing materials.

In the 1830s, however, gambier became useful to the growing textile and leather industry in Britain, thus exports to Europe soared.

Gambier in betel chewing

Gambier is a common ingredient in a 'betel quid' used by Asians for betel chewing. Wrapping an areca nut (Areca catechu), slaked lime and gambier (Uncaria gambir) in a betel leaf (Piper betle) creates a stimulant that is pressed into the cheek.

The Duke and Duchess of Cambridge reading an information panel in the Colonial Garden. These panels illustrate the various stages in the growing and processing of crops such as Cocoa, Coffee, Gambier, Pepper, Clove, Rubber and Nutmeg.

06

This section of the Gardens by the Bay celebrates the world of the tropical plant with six thematic displays that explain everything from the parts of a tree to the evolution of plants; from the World of Palms to the types of fruits and flowers found in the region.

THE WORLD OF PLANTS

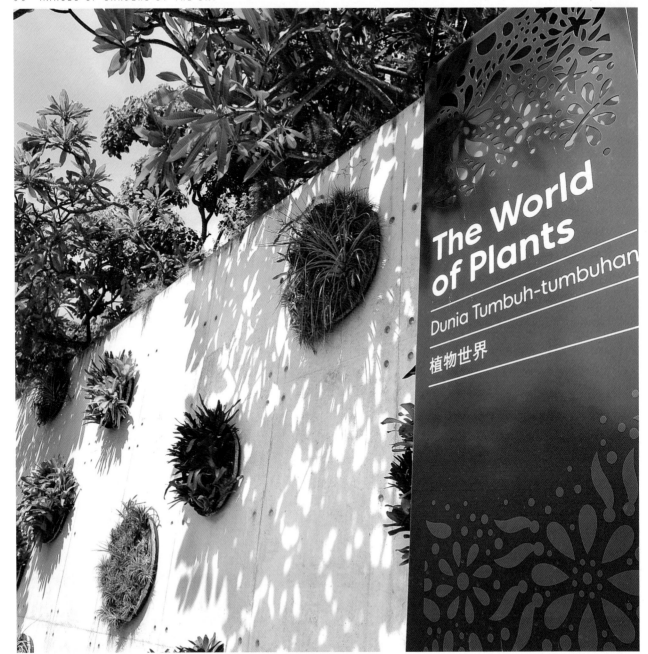

The World
of Plants

Dunia Tumbuh-tumbuhan

植物世界

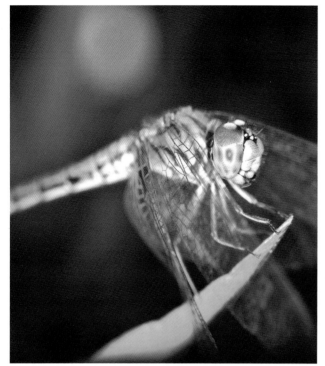

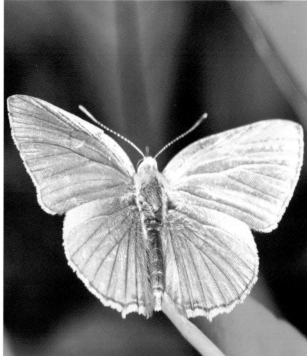

Take the time to observe your surroundings as you walk through this area. Look out for the many insects, birds and other creatures that live here. Do also check out the plants with their unusual fruits and flowers.

THE WORLD OF PLANTS

SECRET LIFE OF TREES

This section of the Gardens looks at the function and evolution of trees and their role in the rainforest. Wall panels describe the different types of bark patterns and tree roots and inform visitors what trees with buttress roots as well as plants with aerial roots look like. There are also cross section displays to show the inside of a tree trunk.

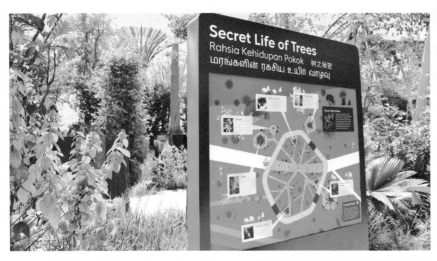

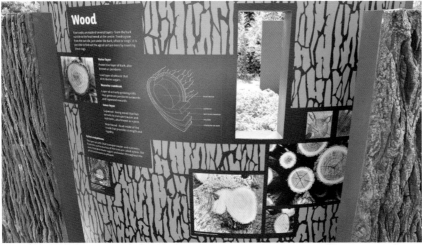

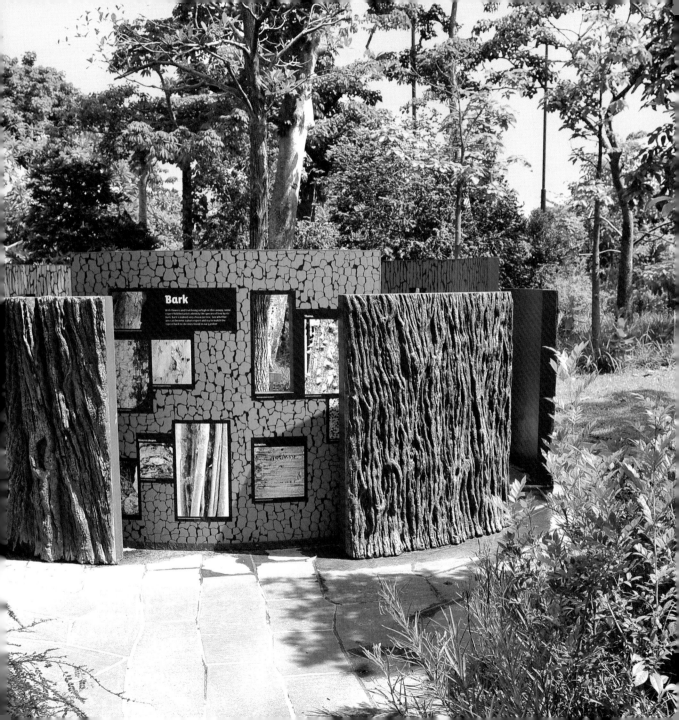

Branches

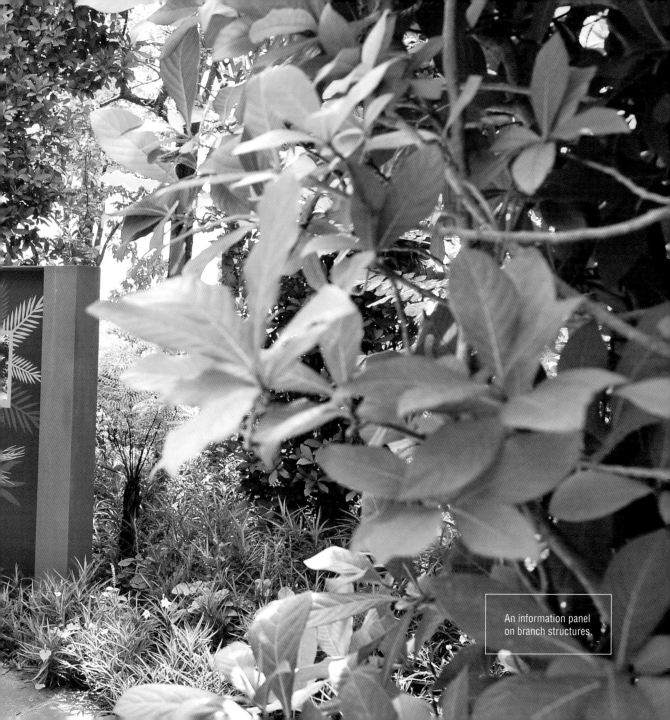

An information panel on branch structures.

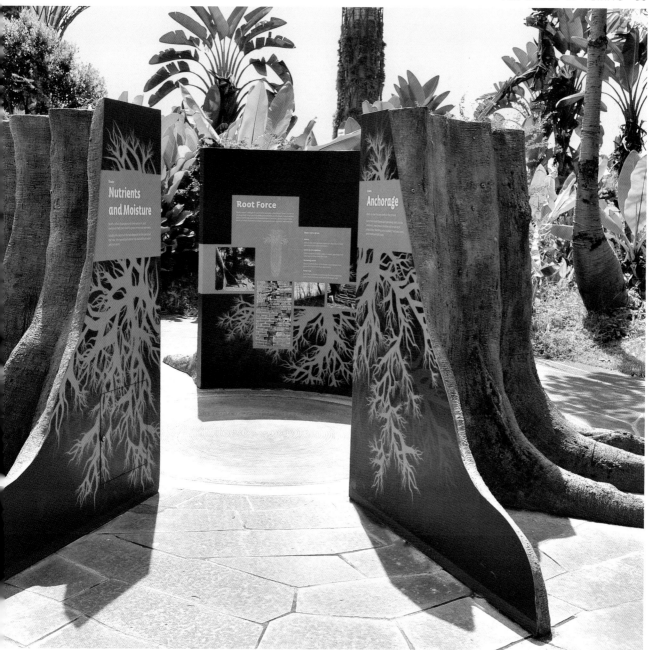

WORLD OF PALMS

This section celebrates the diversity of tropical palms and their versatile use. Palms are grown for both aesthetic purposes and as a food source. Almost all parts of the palm can be used. By-products of the palm such as palm oil are used in comestic products and household products. The panels provide more information on the different types of palms.

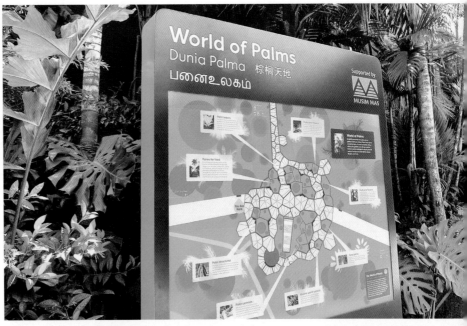

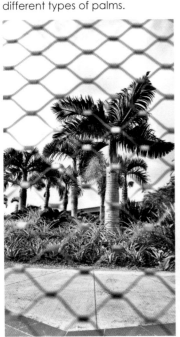

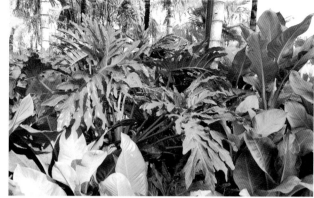

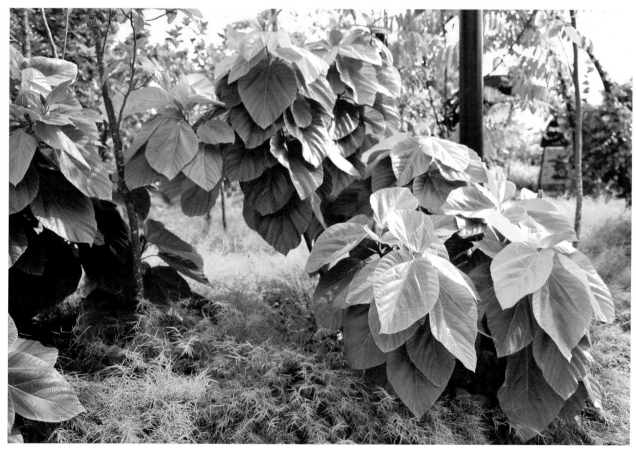

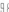

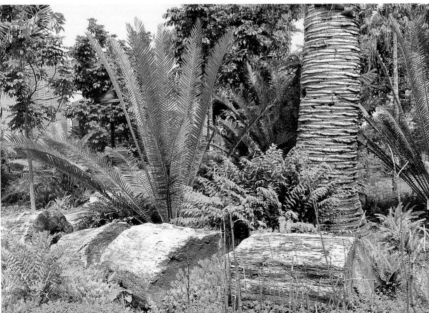
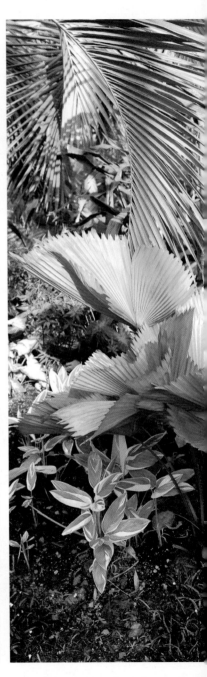

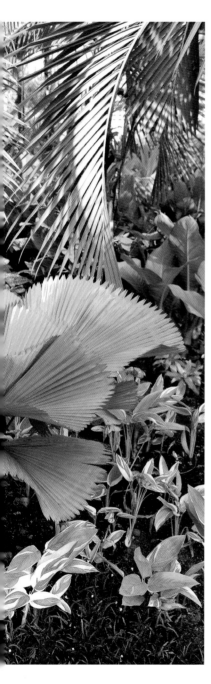

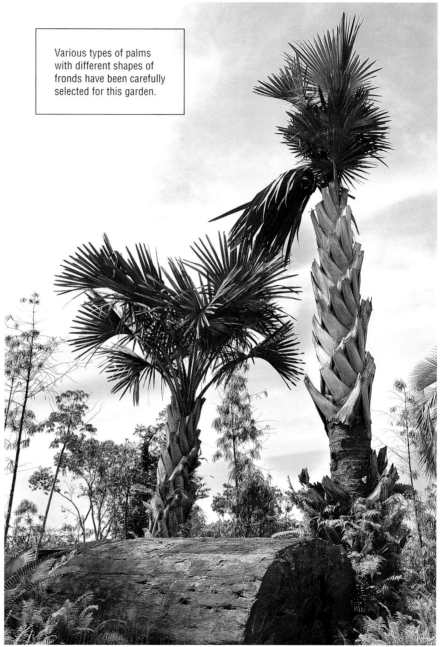

Various types of palms with different shapes of fronds have been carefully selected for this garden.

UNDERSTOREY

The Understorey looks at what lies below the thick canopy of the tropical rainforest. The dark environment that is the forest floor is rich in nutrients as fungi and bacteria break down the fallen twigs, leaves, flowers and fruits. Thousands of insects and plants thrive in the Understorey, adapting to the unique environment to survive.

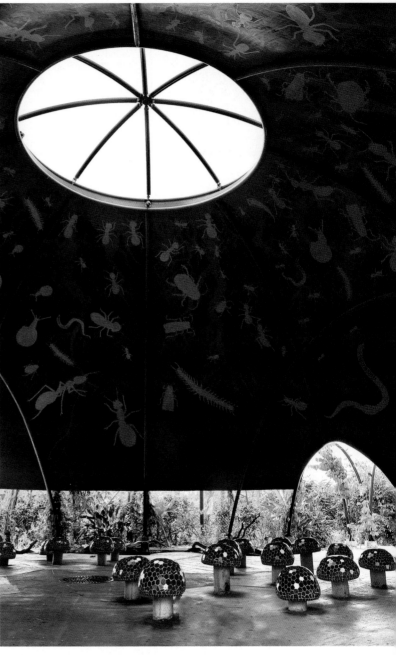

Mushroom Kingdom

Fruiting bodies

There is more to a mushroom than meets the eye — what we see is only the fruiting body of an organism called a fungus, which consists of feeding threads, or hyphae, that travel through the ground and decomposing matter.

Fungi are not plants, being more closely related to animals. They do not produce their energy through photosynthesis, and are either as typically seen a decomposing dead matter or parasites.

Enemies

Some fungi attack living trees, but a great deal more are important for the nutrient cycle in the rainforest.

Decomposers

Many different mushrooms grow on dead and decaying plants and animals, getting their energy by breaking down plant or animal tissue and releasing nutrients that help to feed other living things.

Toadstools, bird's nests and tree brackets

Fungus diversity is simply amazing. Scientists believe that there are still more than half a million species to be described. Amongst the groups you will come across in the rainforest, there are toadstools, bird's nests and bracket fungi.

FRUITS & FLOWERS

This section of the Gardens looks at the diversity of forms and functions of the flowers and fruits. Most plants depend on insects and birds to carry pollen from one flower to another as part of the fertilisation process. As a result, their brightly coloured flowers often give off a lovely fragrance. Animals and birds will eat the ripe fruits and help scatter the seeds. Some fruits also have unusual shapes to appeal to predators.

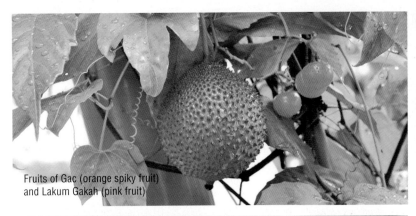

Fruits of Gac (orange spiky fruit) and Lakum Gakah (pink fruit)

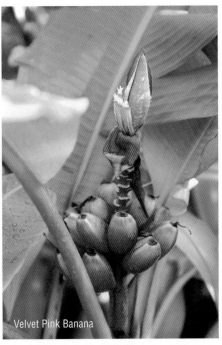

Velvet Pink Banana

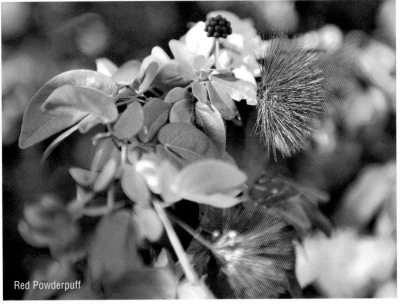

Red Powderpuff

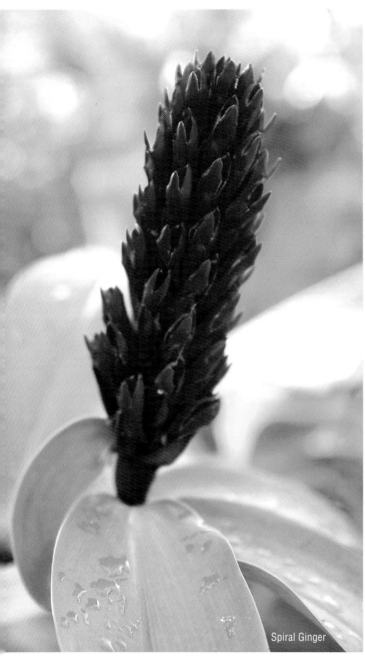

Spiral Ginger

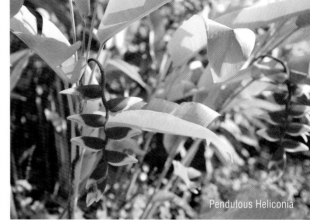

Pendulous Heliconia

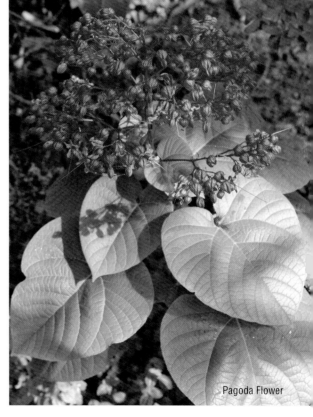

Pagoda Flower

Bougainvillea

Monkey Brush

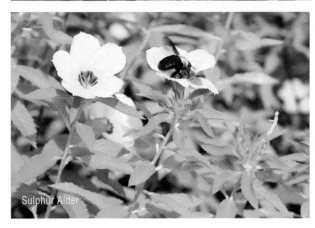

Sulphur Alder

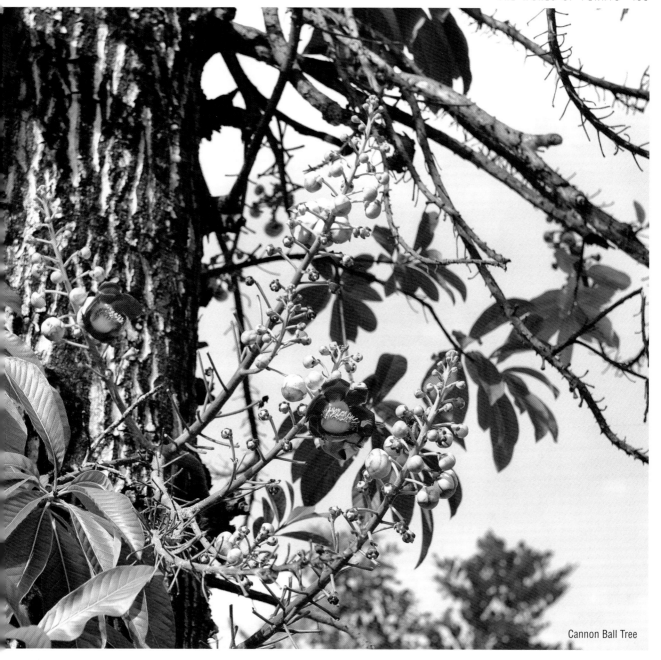

Cannon Ball Tree

Coromandel

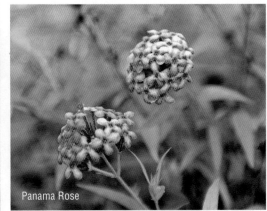

Panama Rose

Trumpet Vine

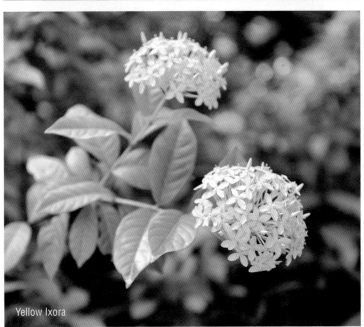

Yellow Ixora

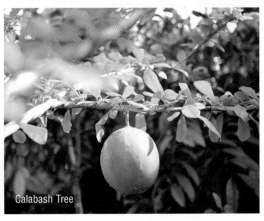

Calabash Tree

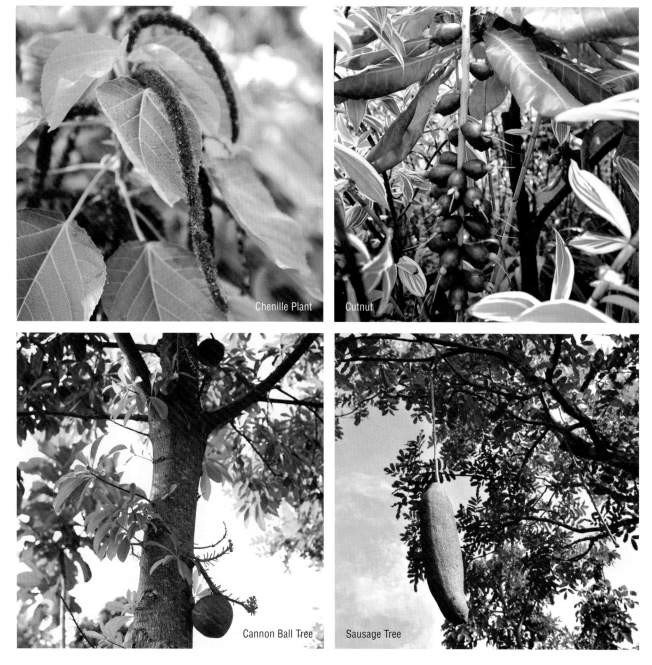

Chenille Plant

Cutnut

Cannon Ball Tree

Sausage Tree

Visitors can find out more about the types of flowers and fruits found in the Gardens and their unique characteristics from these information wall panels.

Wild fruits of the rainforest

Flying high

Javea Cucumber (Alsomitra macrocarpa)

Alsomitra is a large climber in the tropical rainforest, native to the islands of the Malay Archipelago.

Fruits

Football-sized gourds which contain hundreds of...

Delivered in dung

Durio (Malvaceae spp.)

The Durian (Durio zibethinus) Southeast Asia and can be found in many of the region's low-lying forests where it is prized as the king of the fruits...

Cannonball Tree

(Couroupita guianensis)

Look behind

WEB OF LIFE

This section showcases the relationship between the rainforest flora and fauna. These topiaries of the orang utan, wasp, rhino beetle, civet, binturong, pangolin, hornbill and fruit bat are sculpted from the Indian Laurel or Curtain Fig.

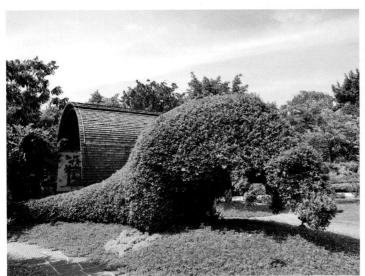

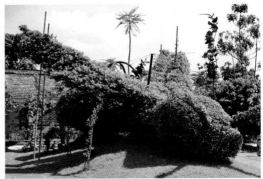

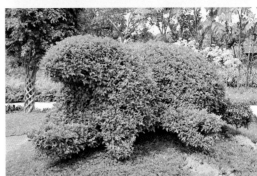

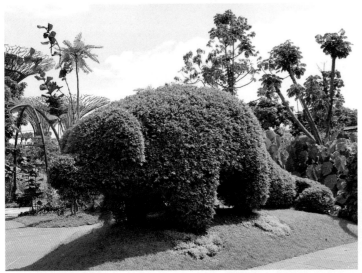

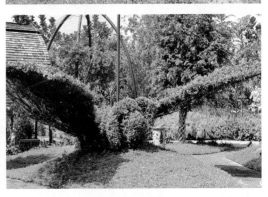

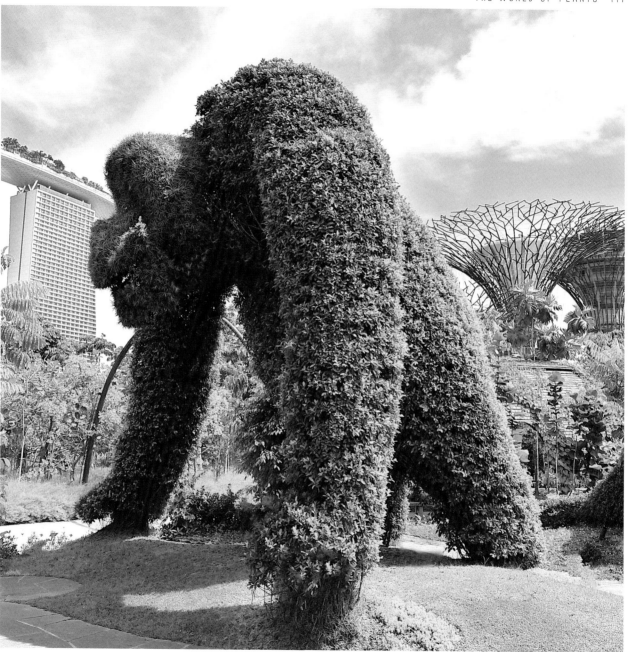

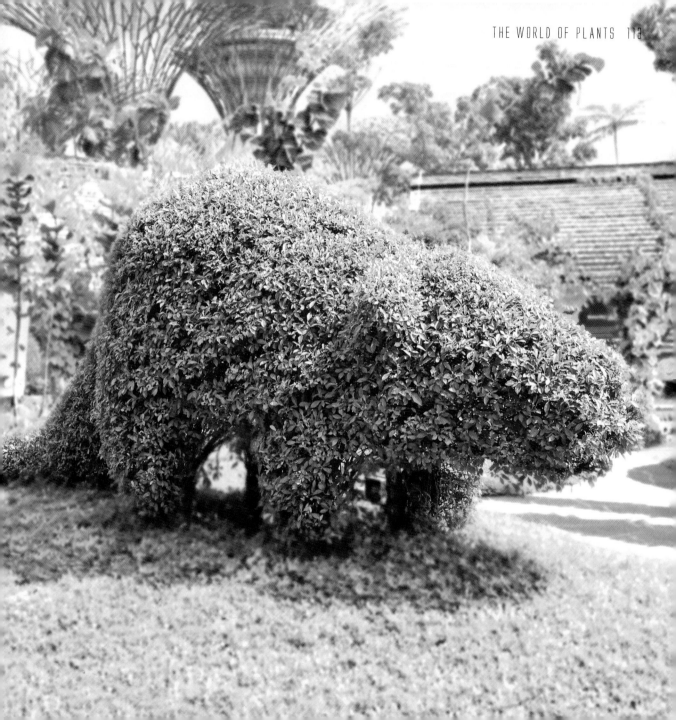

DISCOVERY

This section looks at the evolution of the Earth, tracing the first life forms from 500 million years ago to today. A timeline with key events is illustrated on the wall panels.

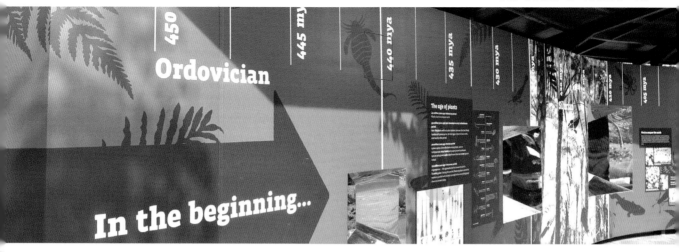

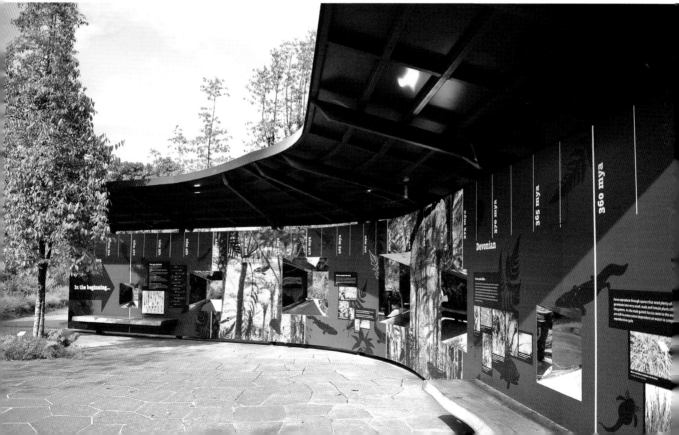

07

A series of interconnected man-made lakes and islands is woven within the network of trails and thematic gardens. Totalling 5 hectares in surface area, the water bodies simulate the natural environment and habitat of the plants and trees.

LAKES & ISLANDS

DRAGONFLY LAKE

Beneath the calm surface of Dragonfly Lake lies
an ingenious underwater pumping system. It draws
in water from the Marina Reservoir, circulates
water through the Gardens and discharges it
back into the reservoir.

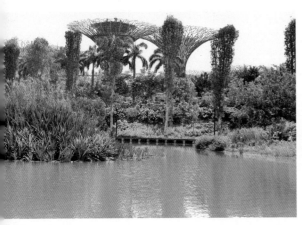

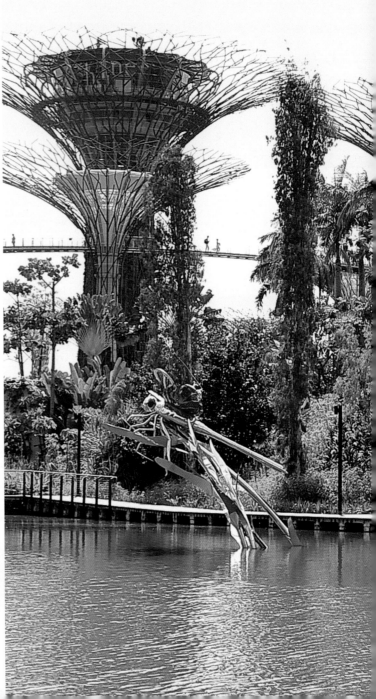

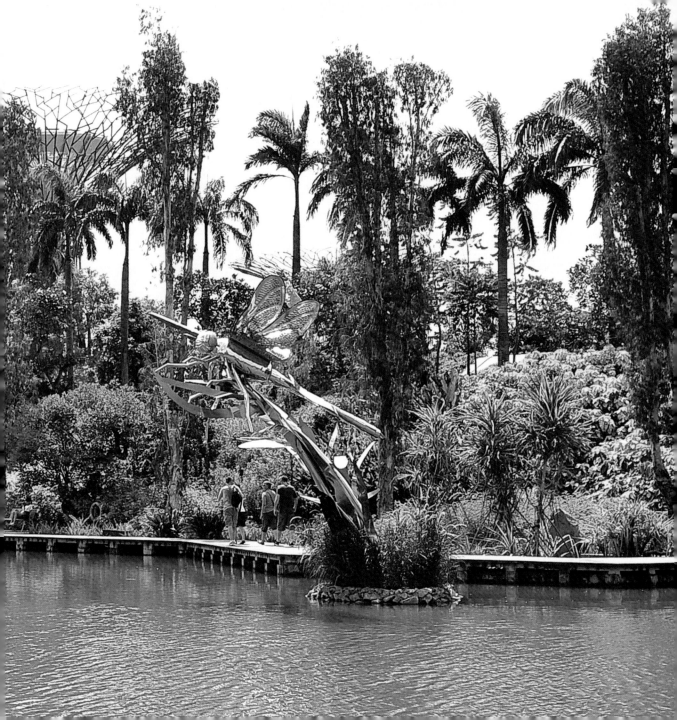

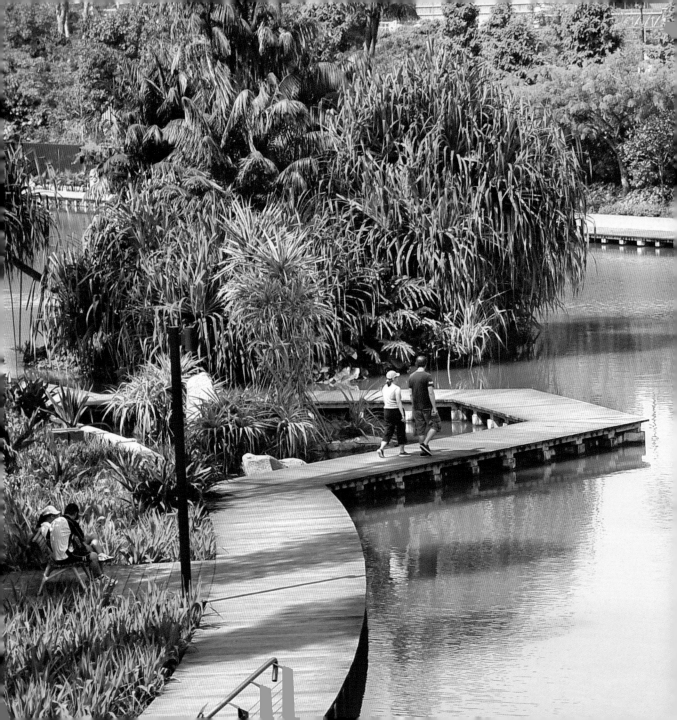

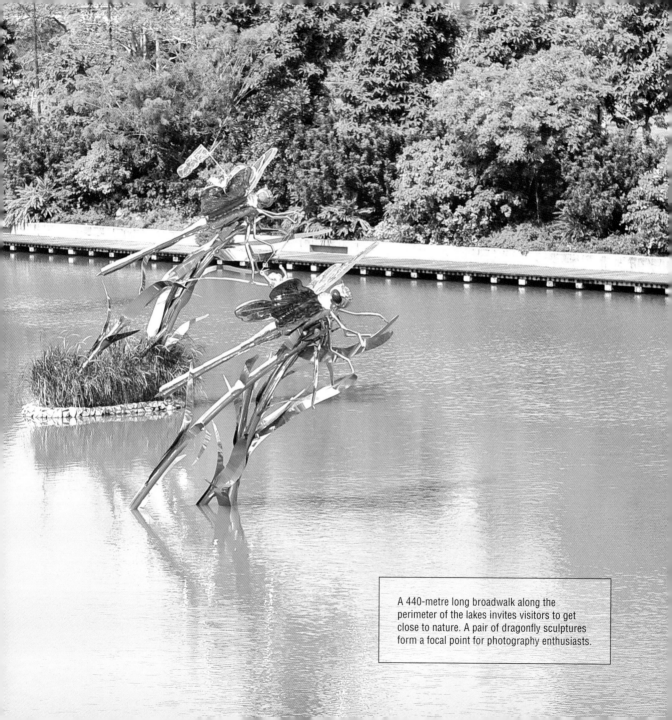

A 440-metre long broadwalk along the perimeter of the lakes invites visitors to get close to nature. A pair of dragonfly sculptures form a focal point for photography enthusiasts.

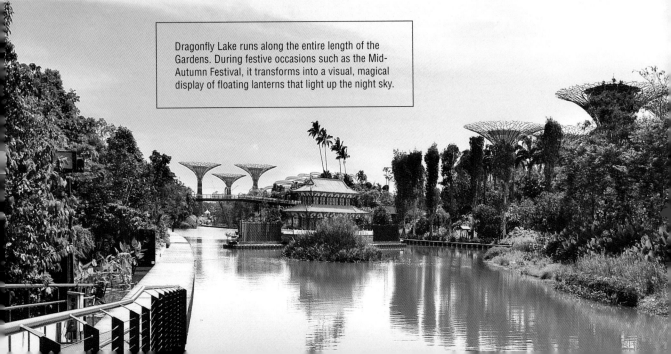

Dragonfly Lake runs along the entire length of the Gardens. During festive occasions such as the Mid-Autumn Festival, it transforms into a visual, magical display of floating lanterns that light up the night sky.

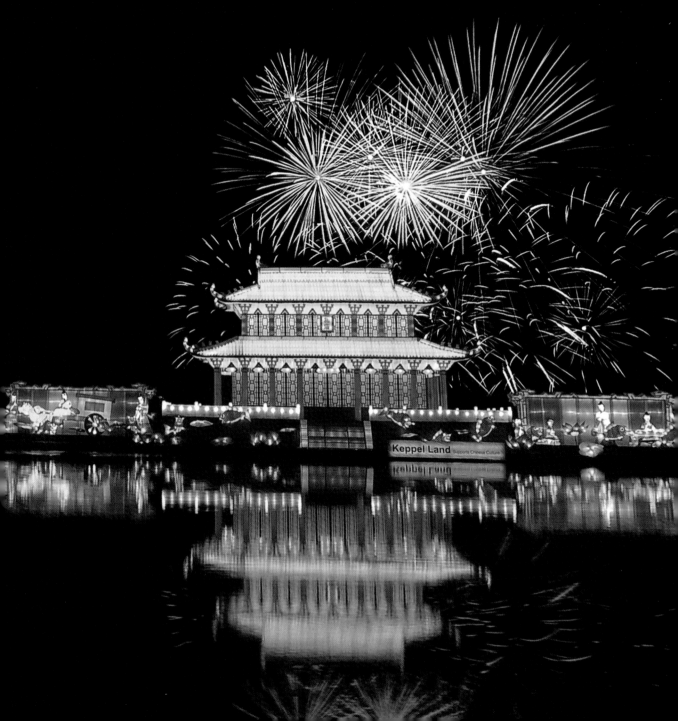

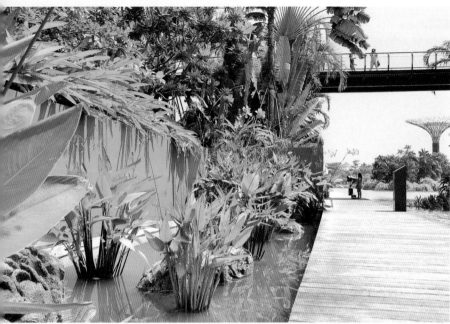

The Dragonfly Bridge provides a seamless connection from Gardens by the Bay to Bayfront MRT Station and Marina Bay Sands.

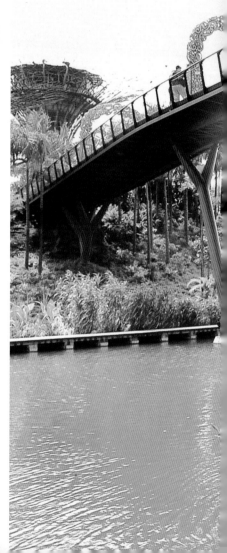

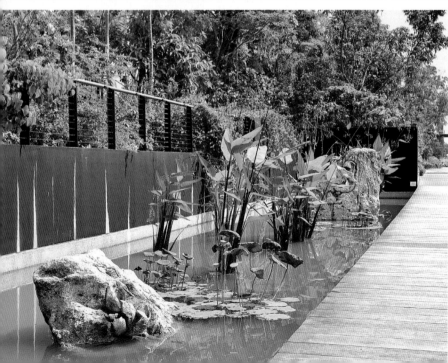

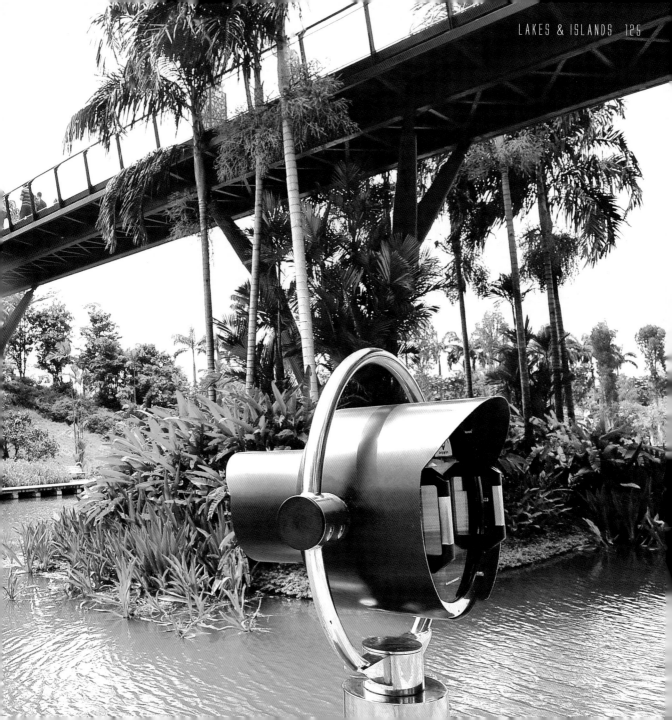

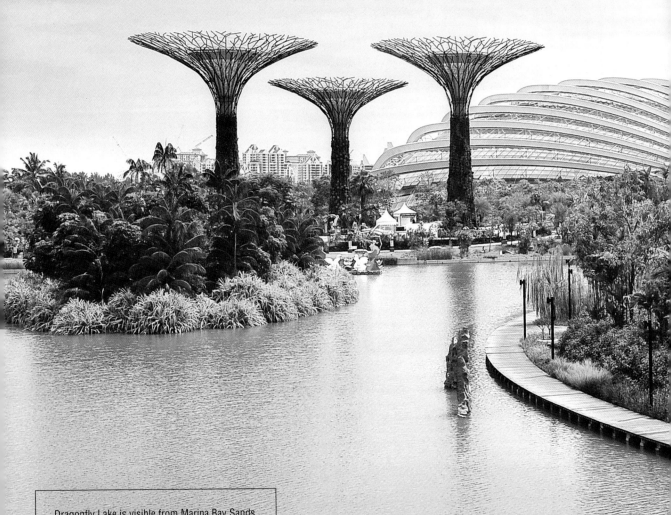

Dragonfly Lake is visible from Marina Bay Sands and forms a second waterfront in the heart of the city centre. A natural filter bed of aquatic reeds and other plants cleanses the water of sediments before it is released back into Marina Reservoir.

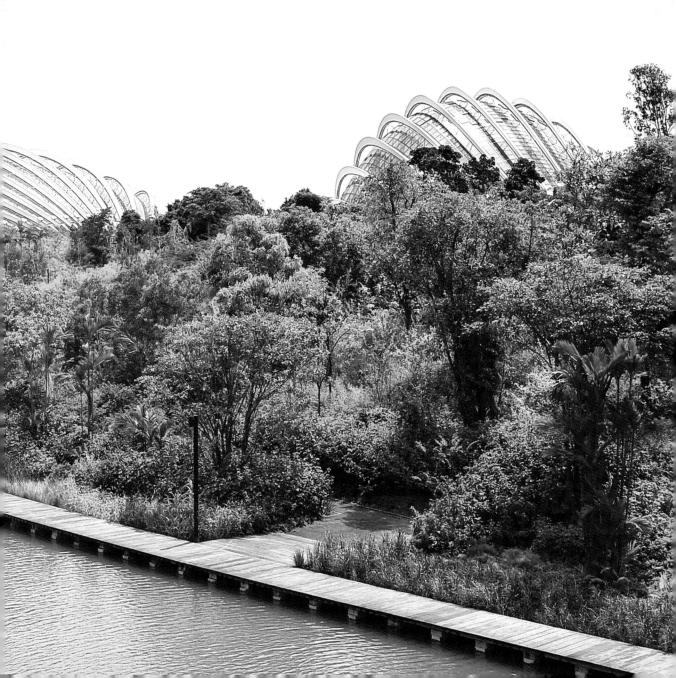

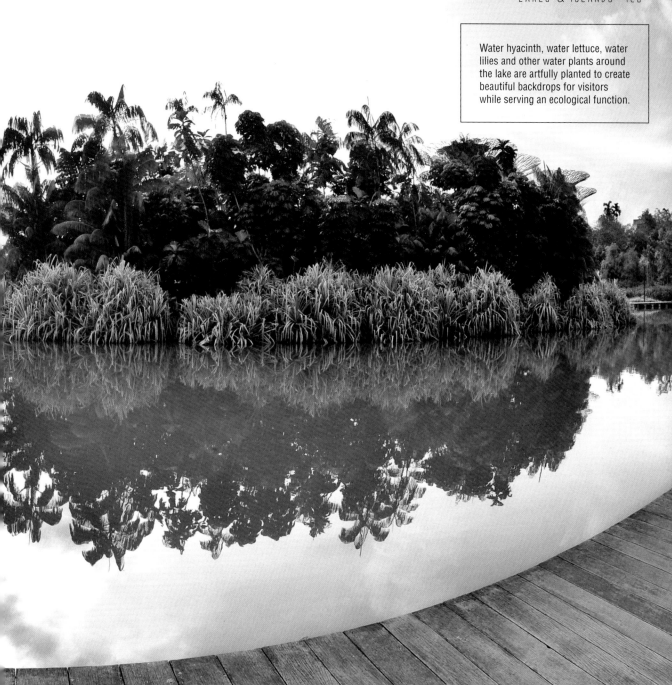

Water hyacinth, water lettuce, water lilies and other water plants around the lake are artfully planted to create beautiful backdrops for visitors while serving an ecological function.

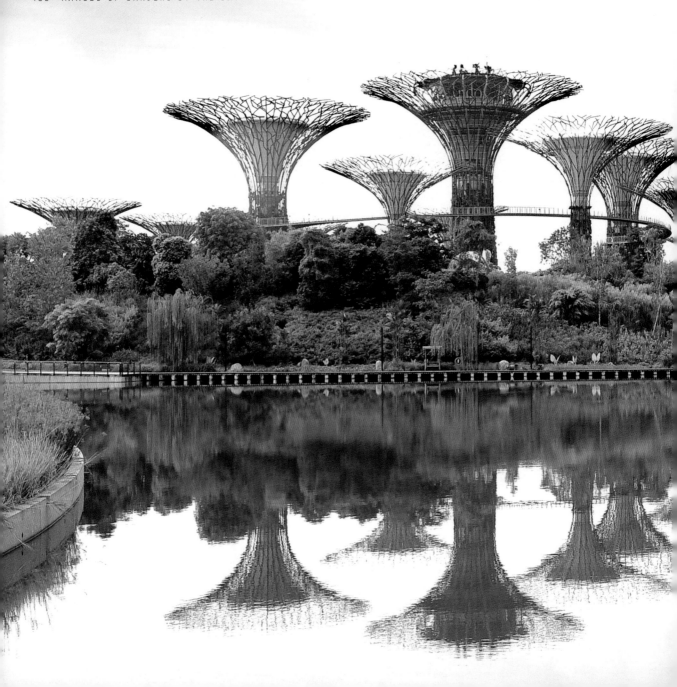

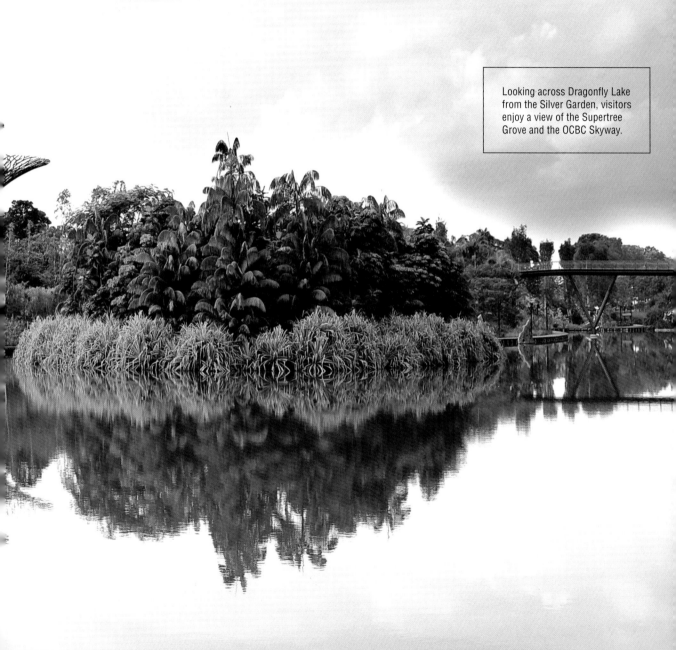

Looking across Dragonfly Lake from the Silver Garden, visitors enjoy a view of the Supertree Grove and the OCBC Skyway.

The Dragonfly is the official motif
and logo of Gardens by the Bay. You
may be able to spot these beautiful
dragonflies in various forms as
sculptures and other motifs flying
between the plants and lakes.

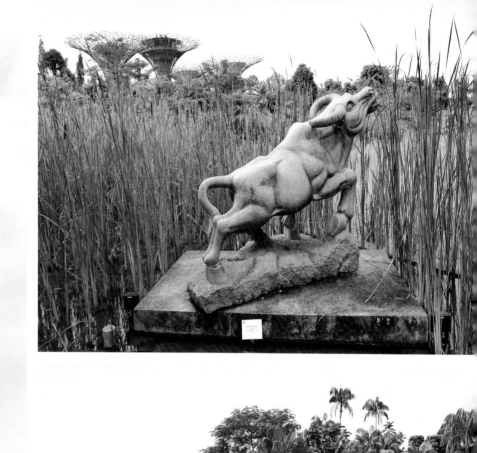

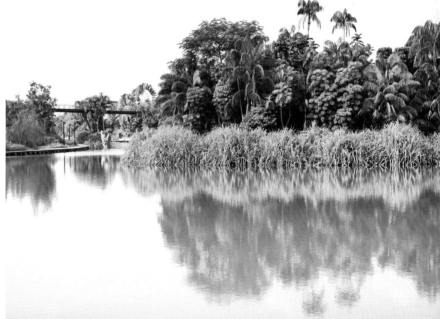

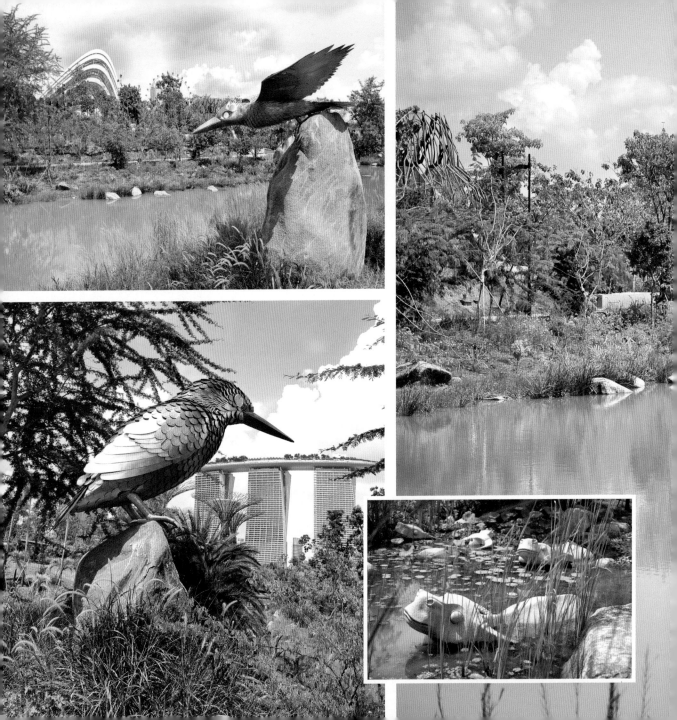

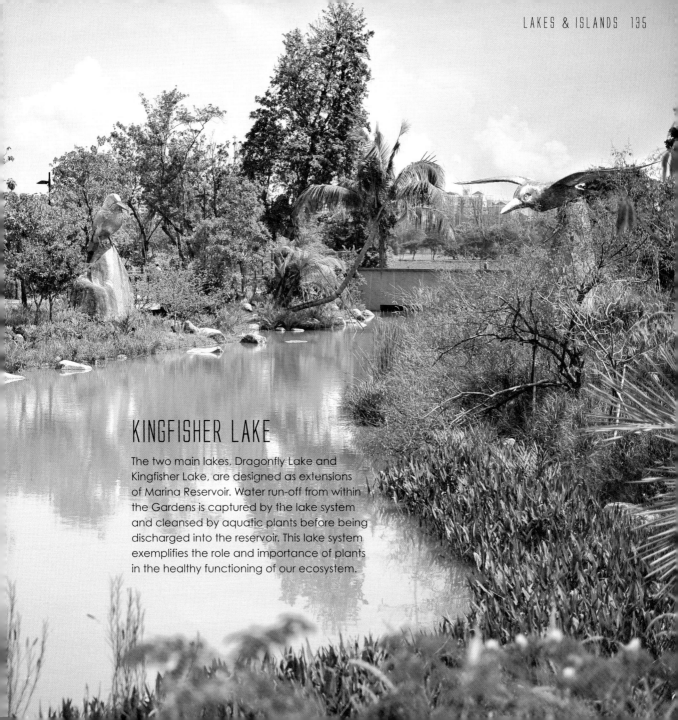

KINGFISHER LAKE

The two main lakes, Dragonfly Lake and Kingfisher Lake, are designed as extensions of Marina Reservoir. Water run-off from within the Gardens is captured by the lake system and cleansed by aquatic plants before being discharged into the reservoir. This lake system exemplifies the role and importance of plants in the healthy functioning of our ecosystem.

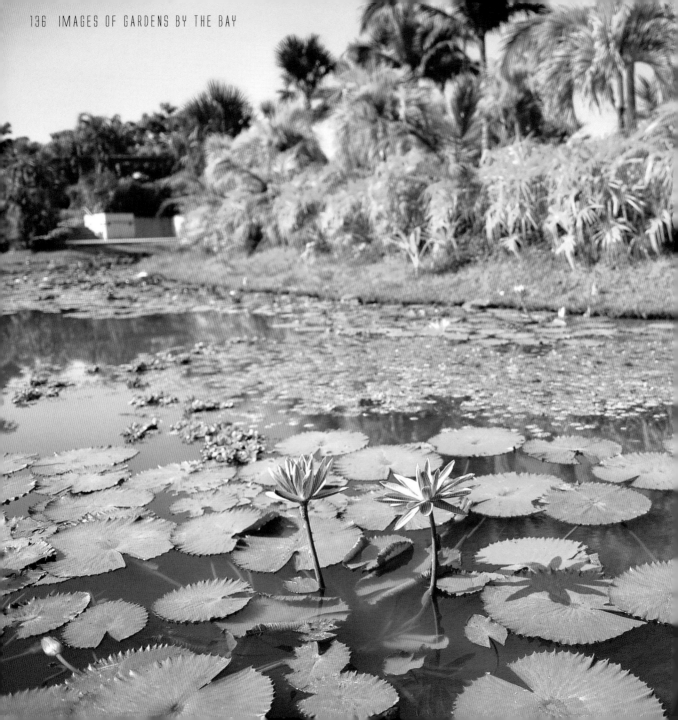

WATER LILY POND

One of the smaller water bodies at the Gardens, the Water Lily Pond is planted with various species of the plant which gives it its name.

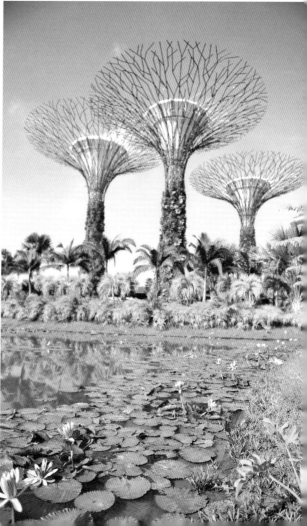

VICTORIA LILY POND

The smallest of the ponds, Victoria Lily Pond provides an intimate retreat for visitors to the Gardens. Set in its own enclave surrounded by lush landscaping, it is a tranquil escape from other busier sections of the main Gardens.

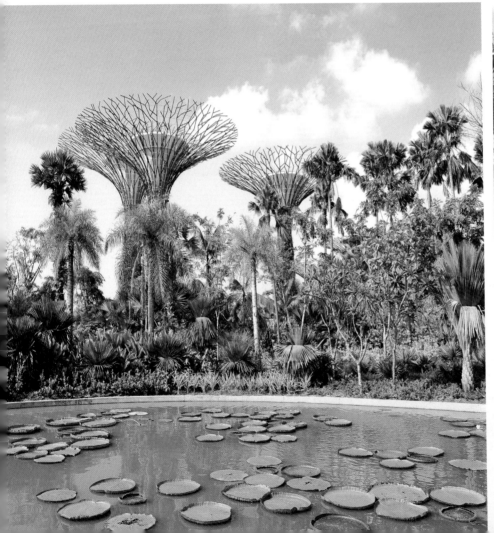
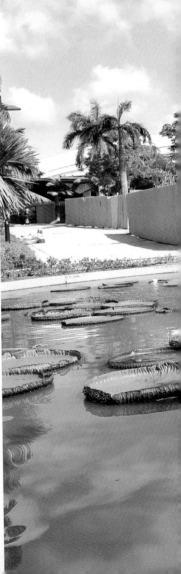

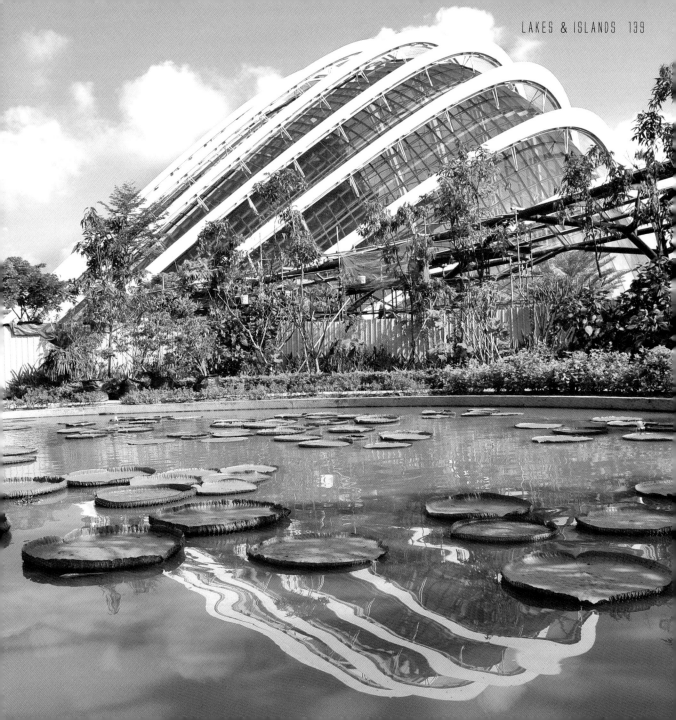

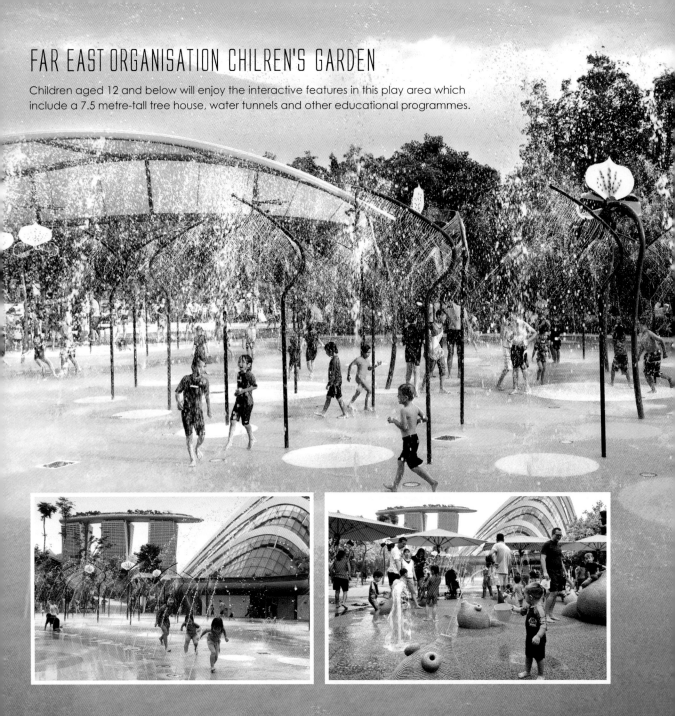

FAR EAST ORGANISATION CHILREN'S GARDEN

Children aged 12 and below will enjoy the interactive features in this play area which include a 7.5 metre-tall tree house, water tunnels and other educational programmes.

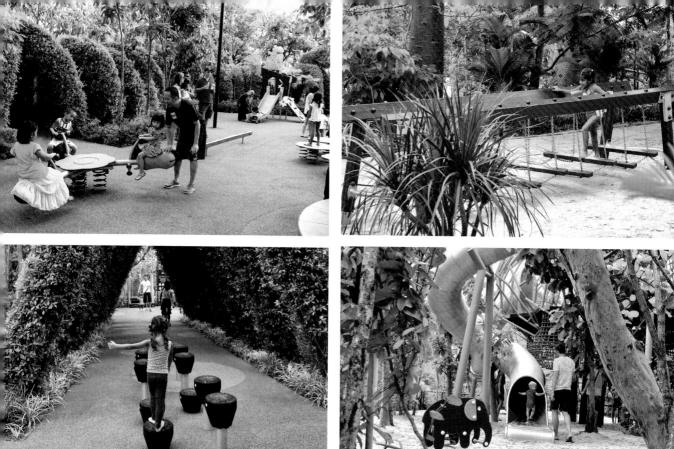
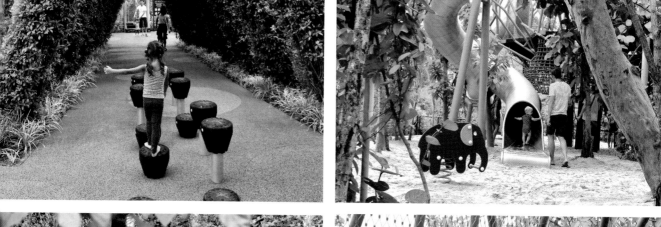
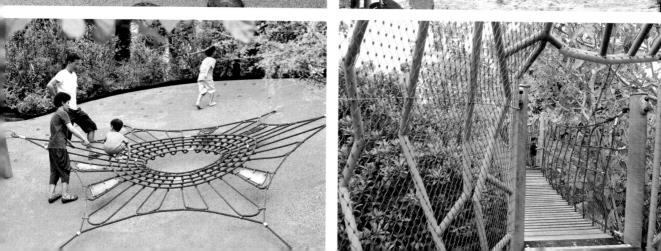

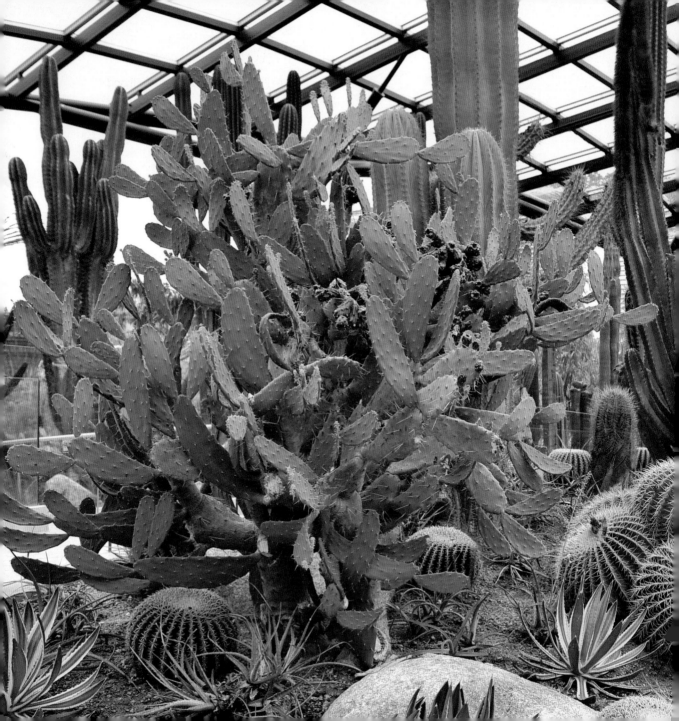

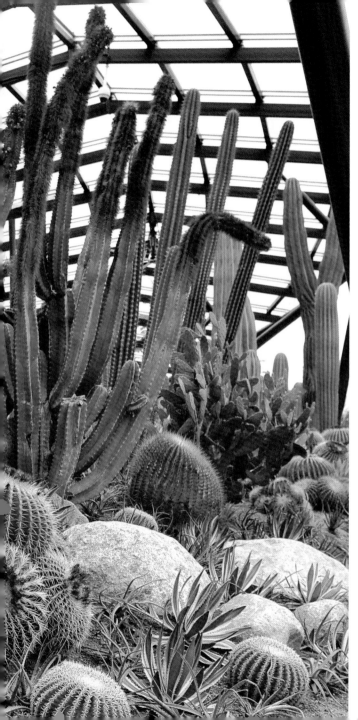

SUN PAVILION

This area is home to the largest cacti and succulent collections in Southeast Asia featuring over 1,000 plants from the deserts of Madagascar, Mexico, Argentina, Kenya, Brazil and more.

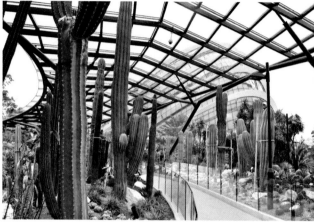

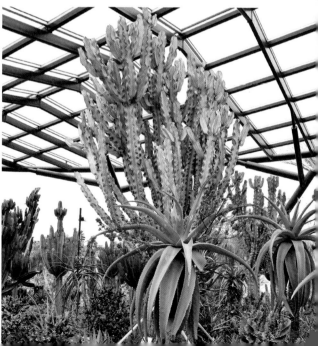

THE CANYON

Discover more than 60 one-of-a-kind ancient rock sculptures sourced from Shandong, China. Landscape architect Jun-ichi Inada arranged them along a 400-metre-long dragon-shaped trail.

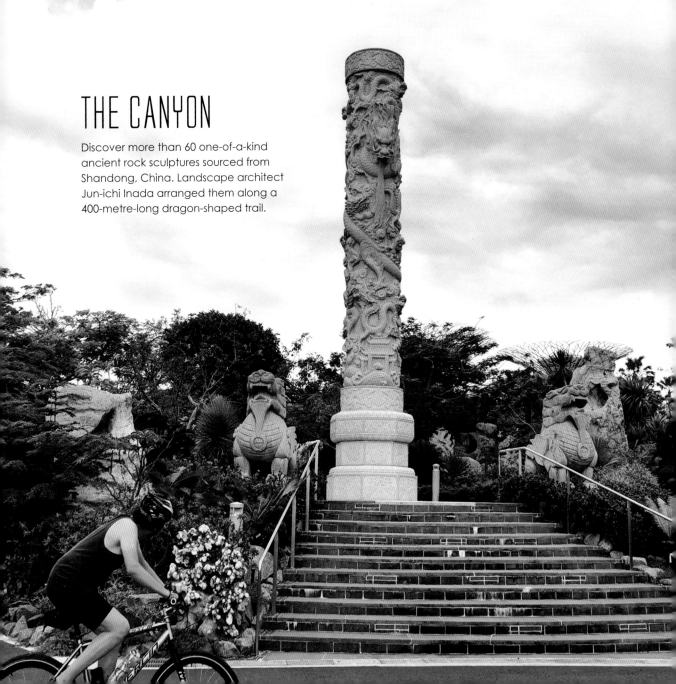

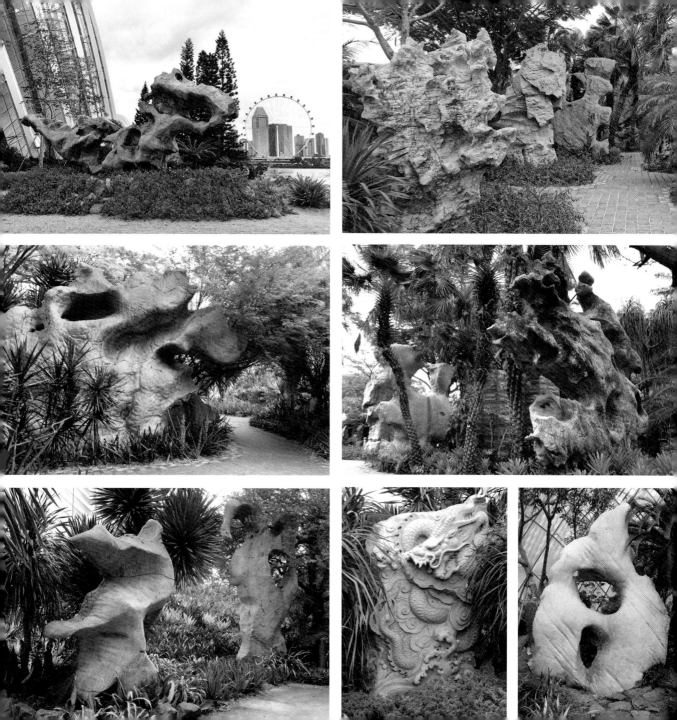

THE MEADOW

With a capacity for up to 30,000 people, The Meadow is Singapore's largest outdoor garden event venue. It has hosted concerts, festivals and carnivals as well as product launches and sports-themed events. Here are some of these events.

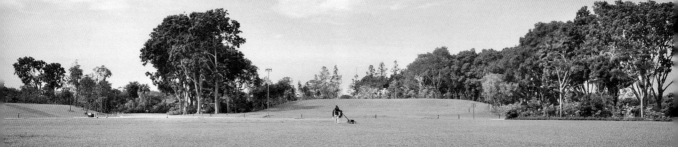

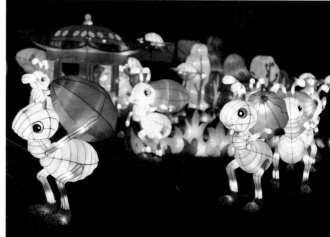

SINGAPORE GARDEN FESTIVAL

One of the events held at The Meadow was the Singapore Garden Festival. The 2014 show featured 15 Landscape and Fantasy Gardens, 14 Floral Windows to the World displays, eight Balcony Gardens, seven Table Top Floral displays, six miniature gardens and an Orchid Extravaganza featuring some 18,000 plants and more than 40 orchid species and hybrids.

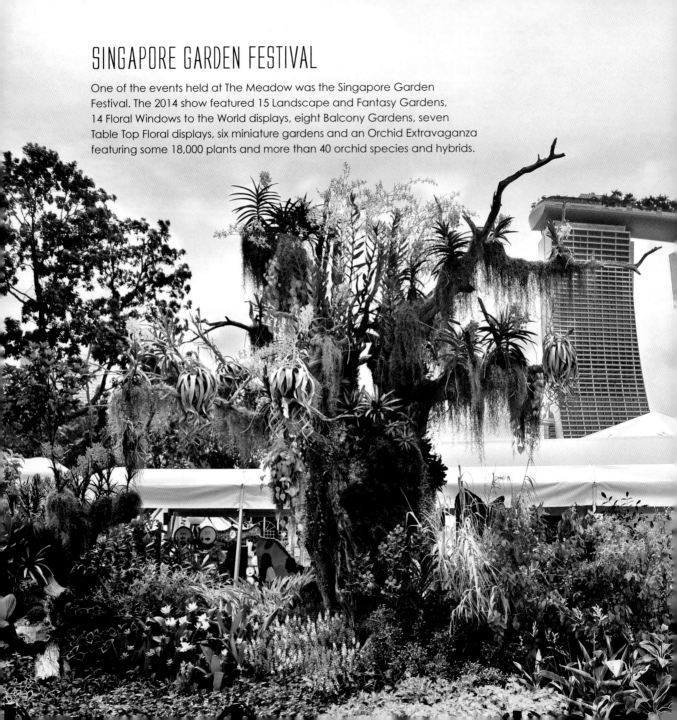

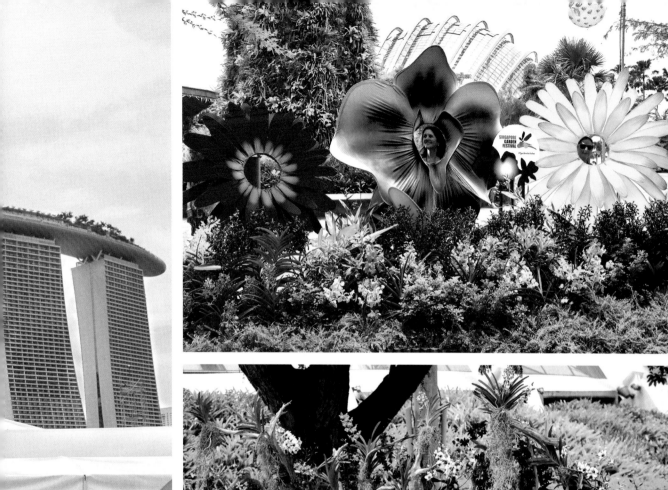

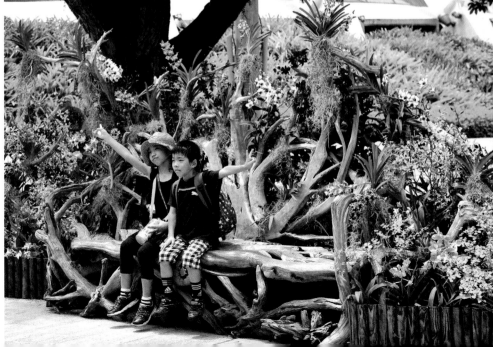

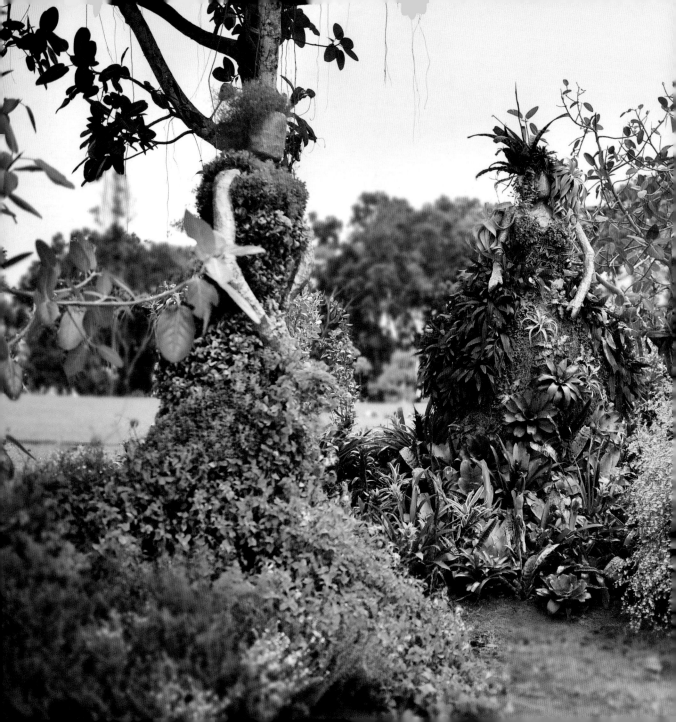

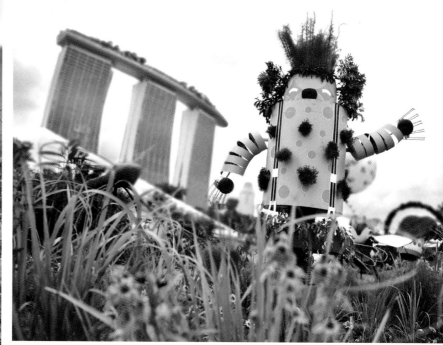

SATAY BY THE BAY

The casual dining space offers excellent views of the waterfront while feasting on local hawker fare such as satay, BBQ chicken wings, chicken rice, popiah and more. Also available are options for steamboat and various variety of live seafood.

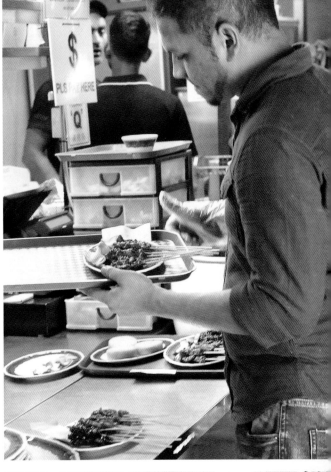

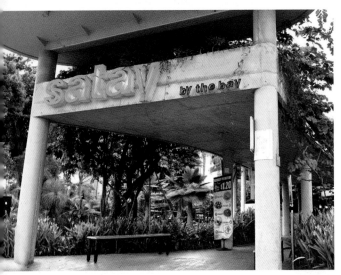

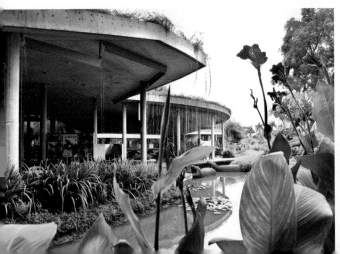

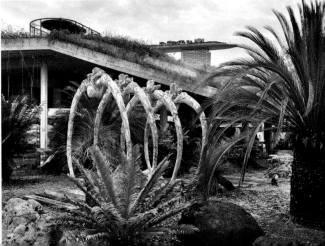

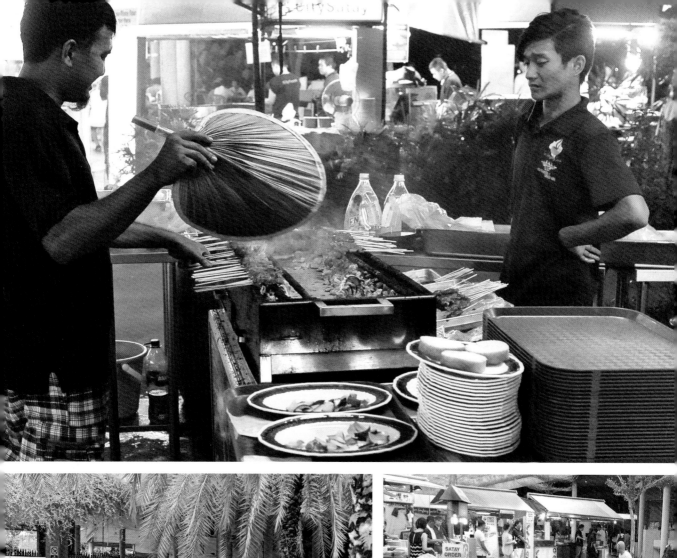

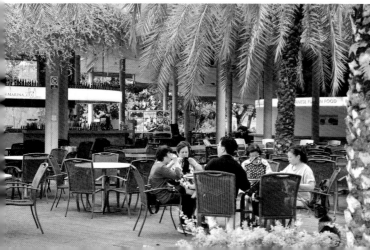

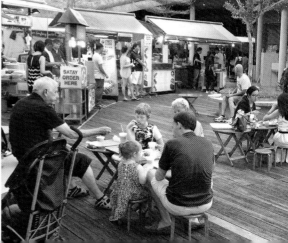

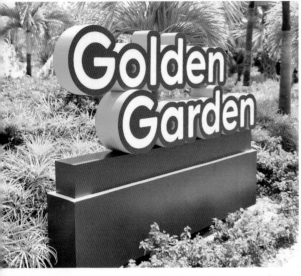

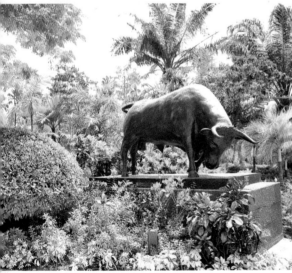

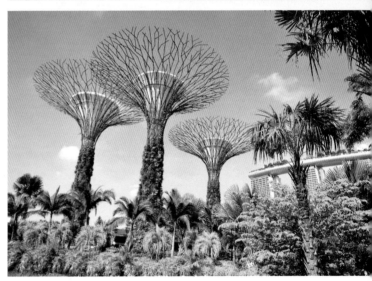

GOLDEN GARDEN

A cluster of three Supertrees forms part of the Golden Garden. This garden is planted with ferns, flowers and shrubs that have a golden hue as gold symbolises prosperity. A statue of a bull which is a sign of a good run in the stock market adds to the theme of wealth and success.

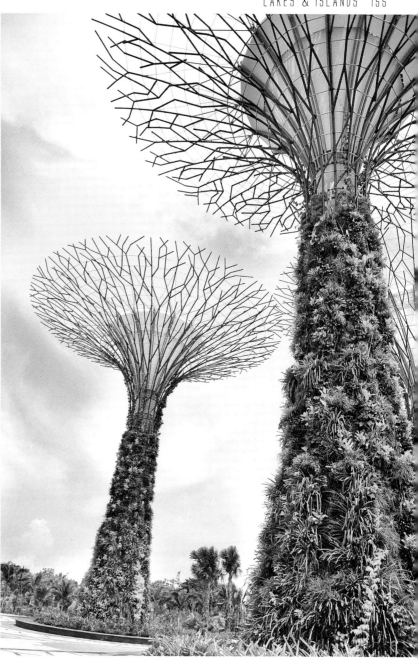

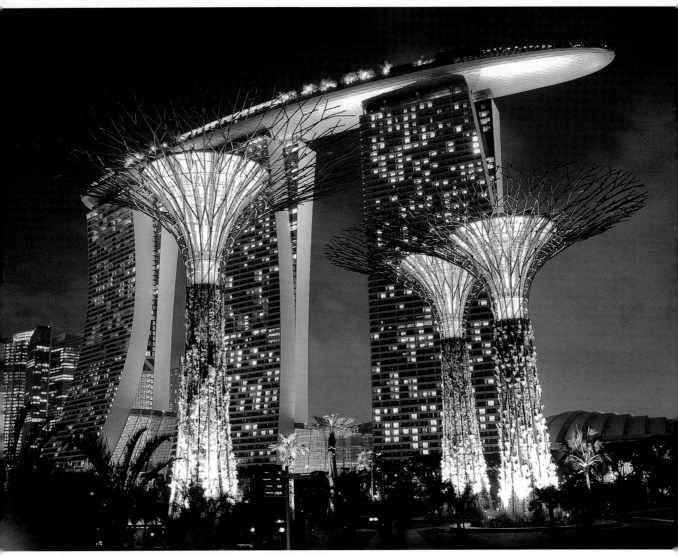

SILVER GARDEN

A counterpart to the Golden Garden, the Silver Garden is planted with silver (white) themed plants. Located between Dragonfly Lake and the Forest Dome, it is also home to a cluster of three Supertrees.

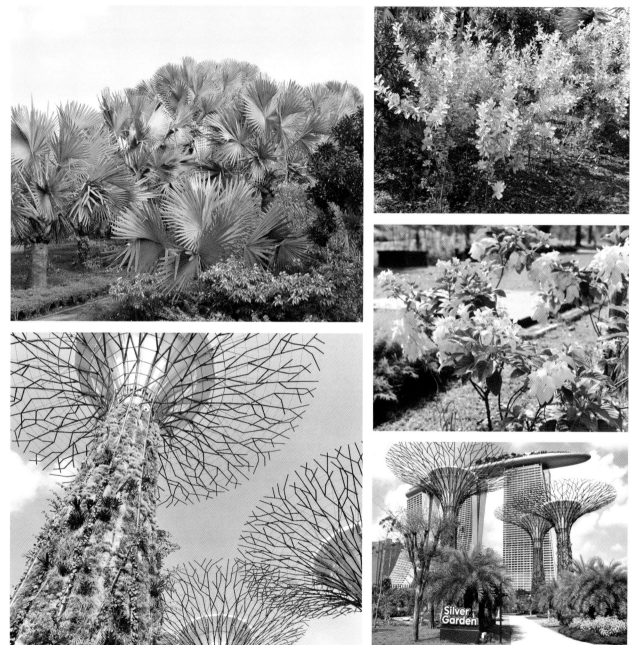

Silver Garden

08

SUPERTREE GROVE

Supertrees are uniquely designed vertical gardens ranging from 25 to 50 metres in height (9 to 16 storeys high) found in the Gardens. More than 160,000 plants from 30 countries grow on these magnificent structures.

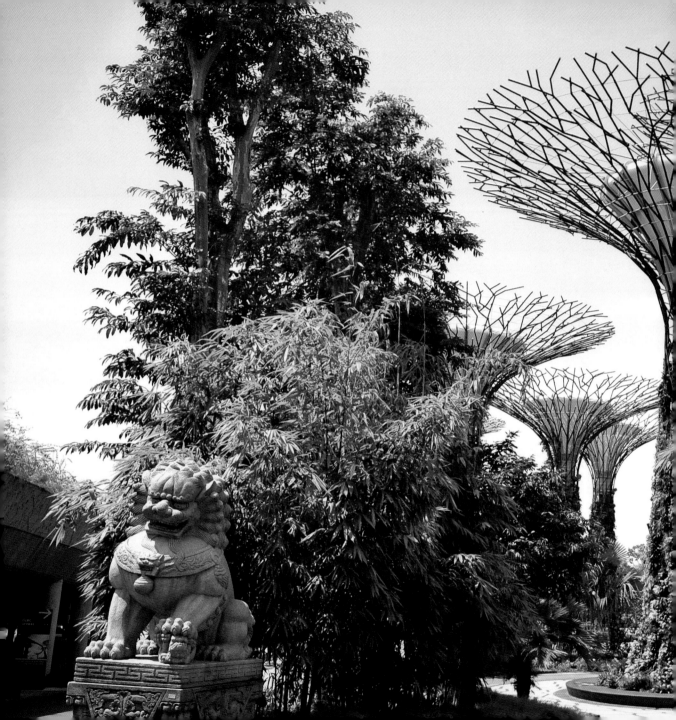

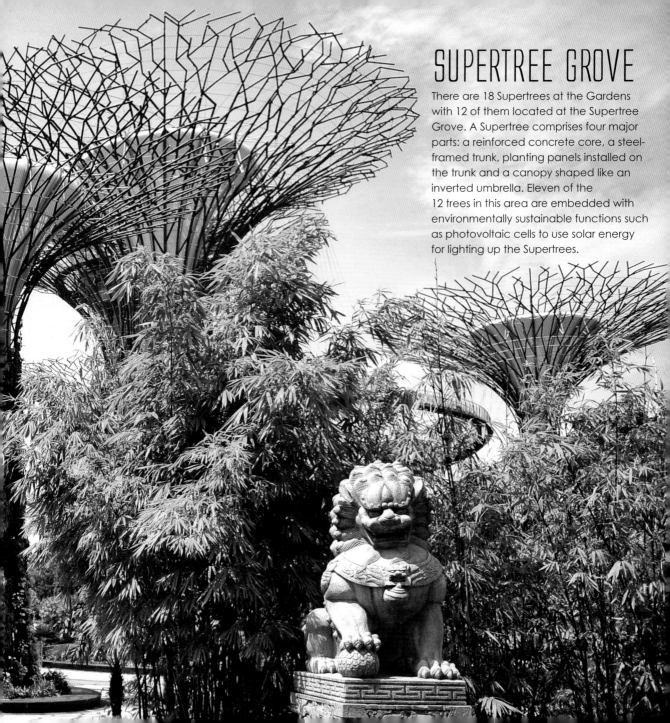

SUPERTREE GROVE

There are 18 Supertrees at the Gardens with 12 of them located at the Supertree Grove. A Supertree comprises four major parts: a reinforced concrete core, a steel-framed trunk, planting panels installed on the trunk and a canopy shaped like an inverted umbrella. Eleven of the 12 trees in this area are embedded with environmentally sustainable functions such as photovoltaic cells to use solar energy for lighting up the Supertrees.

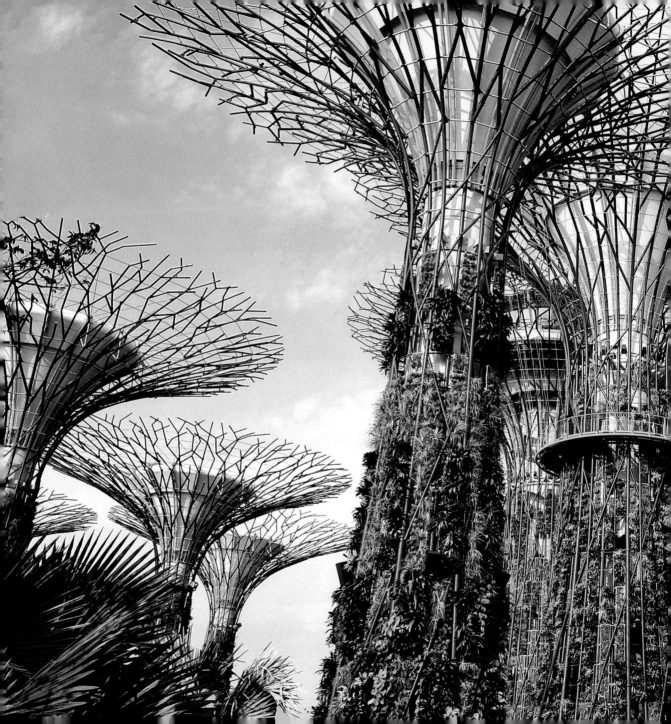

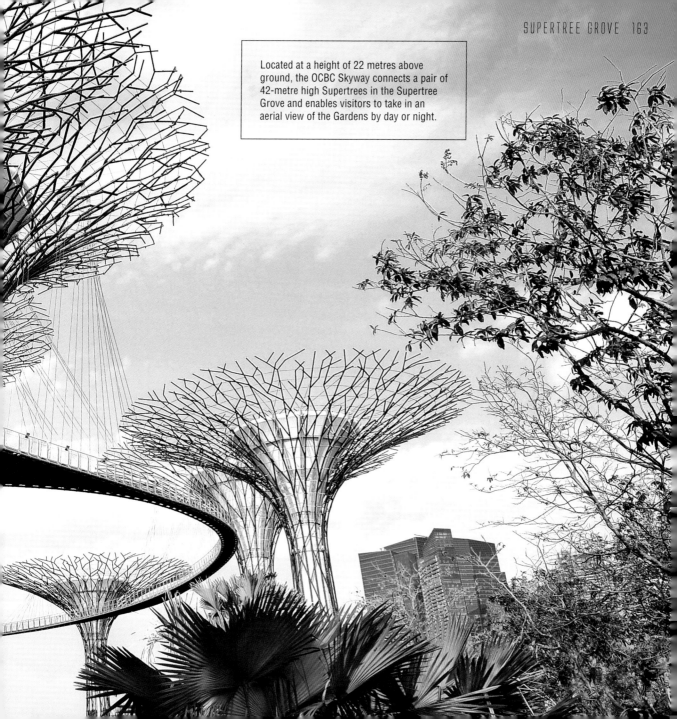

Located at a height of 22 metres above ground, the OCBC Skyway connects a pair of 42-metre high Supertrees in the Supertree Grove and enables visitors to take in an aerial view of the Gardens by day or night.

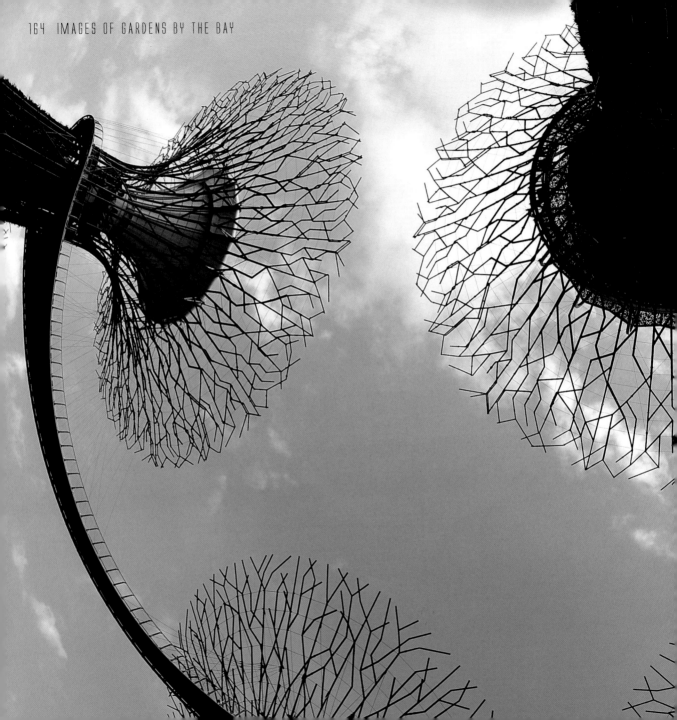

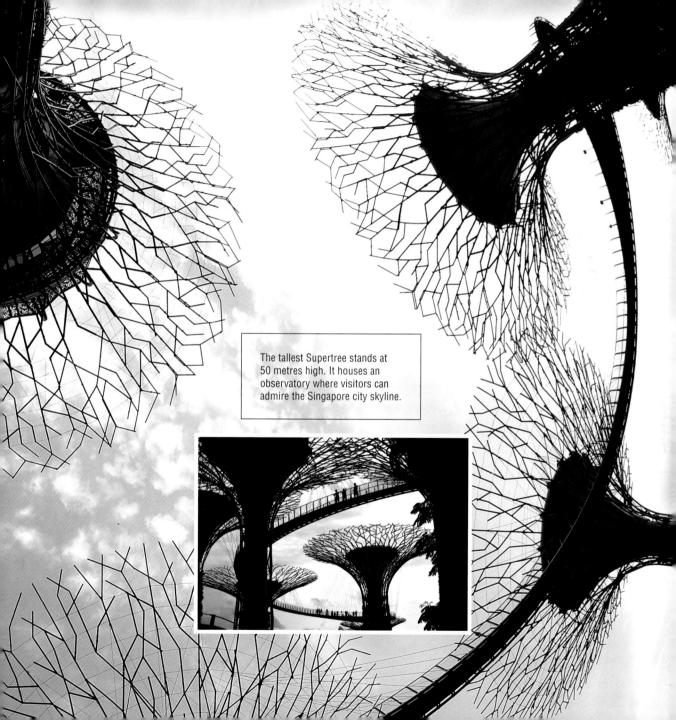

The tallest Supertree stands at 50 metres high. It houses an observatory where visitors can admire the Singapore city skyline.

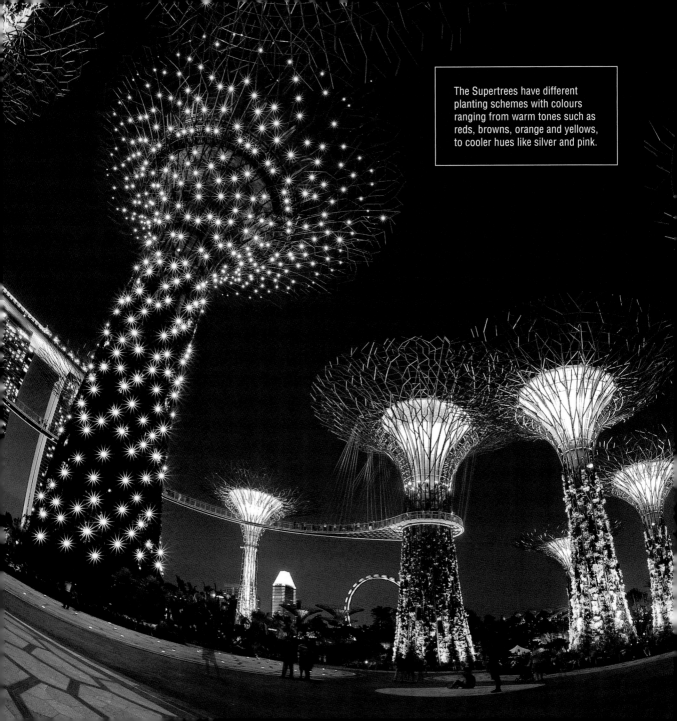

The Supertrees have different planting schemes with colours ranging from warm tones such as reds, browns, orange and yellows, to cooler hues like silver and pink.

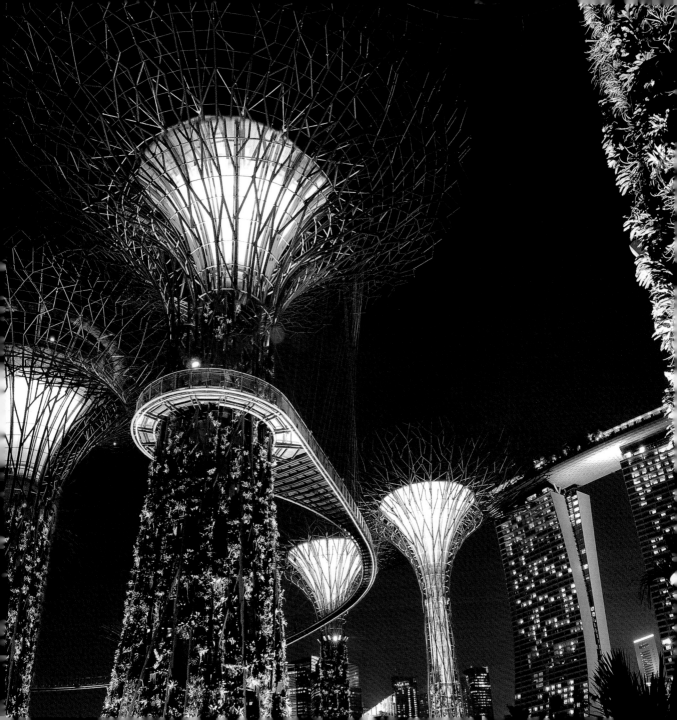

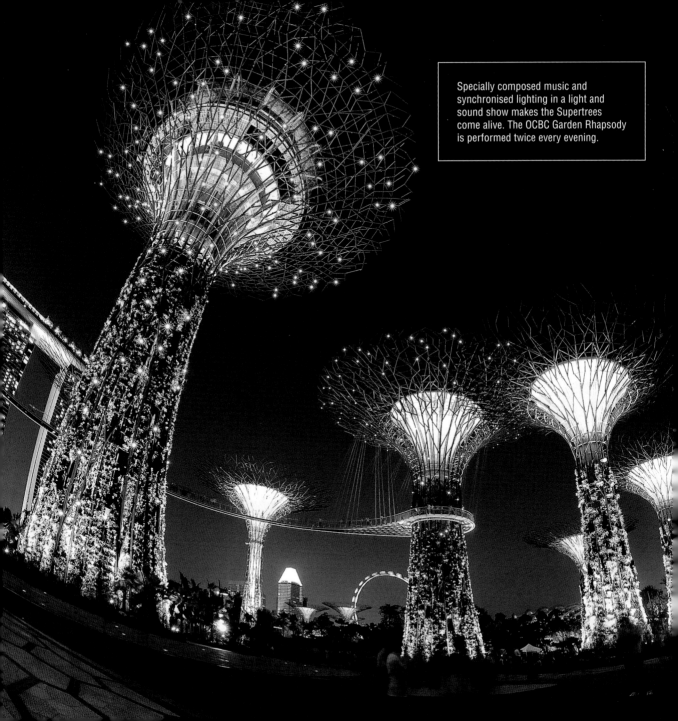

Specially composed music and synchronised lighting in a light and sound show makes the Supertrees come alive. The OCBC Garden Rhapsody is performed twice every evening.

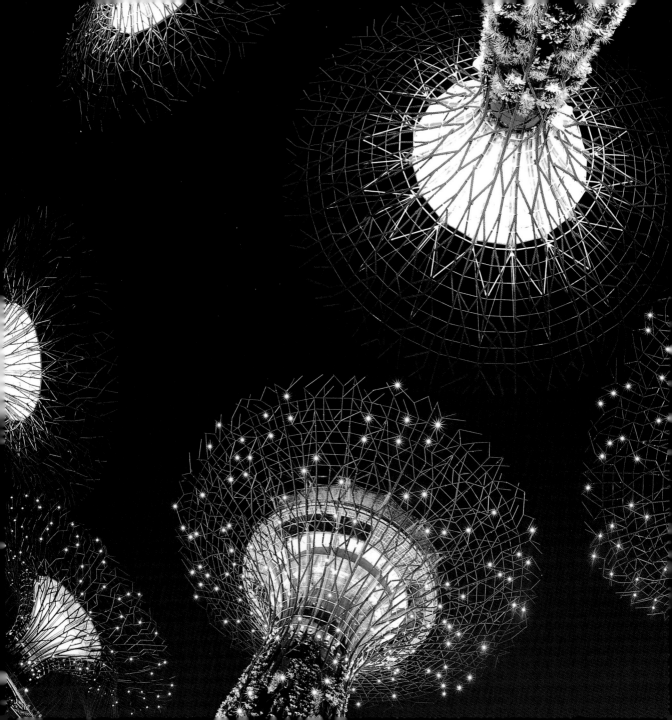

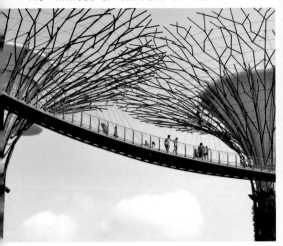

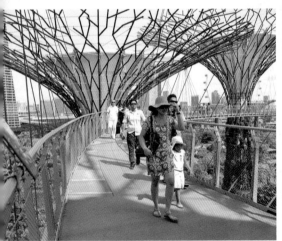

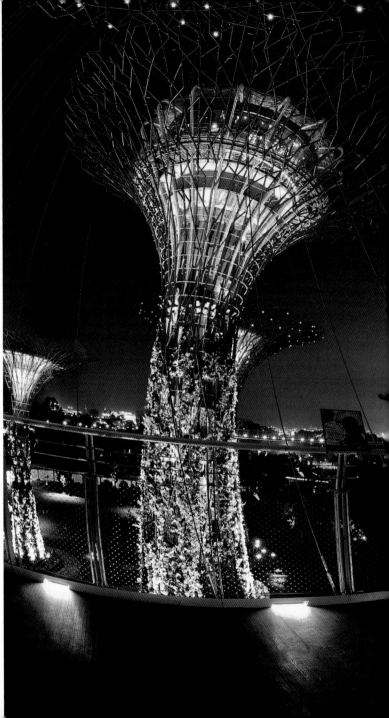

OCBC SKYWAY

The OCBC Skyway is a 128-metre long aerial walkway linking two 42-metre high Supertrees. Visitors can take a lift up the core of the Supertree and enjoy another perspective of the Gardens as they make their way along the Skyway. There is a fee for entry to the Skyway.

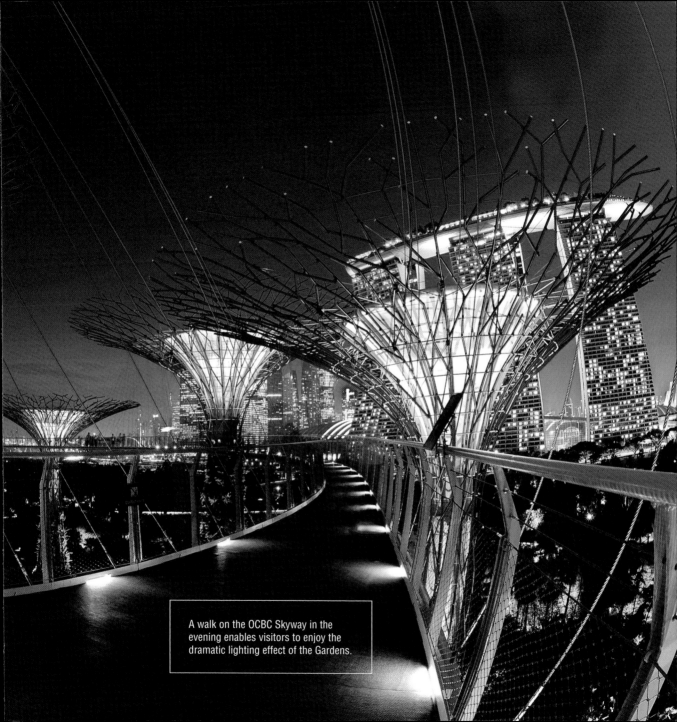

A walk on the OCBC Skyway in the evening enables visitors to enjoy the dramatic lighting effect of the Gardens.

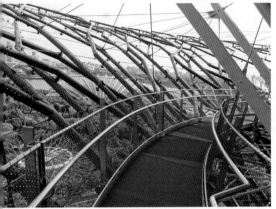

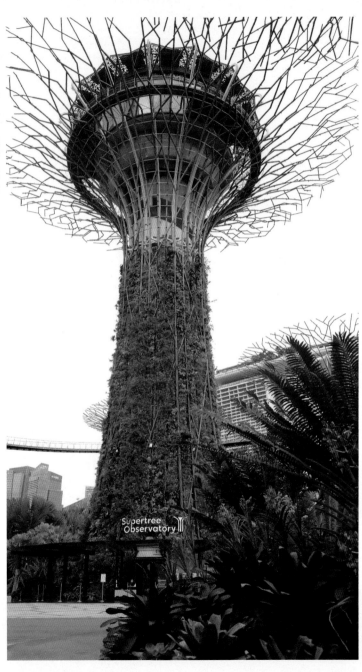

SUPERTREE OBSERVATORY

The canopy of the tallest Supertree offers unblocked city views from the indoor observatory through its full-height glass windows. Visitors can try out the digital learning experiences. They can also explore the outdoor walkway and visit the open-air rooftop deck, the highest point at 50m above ground.

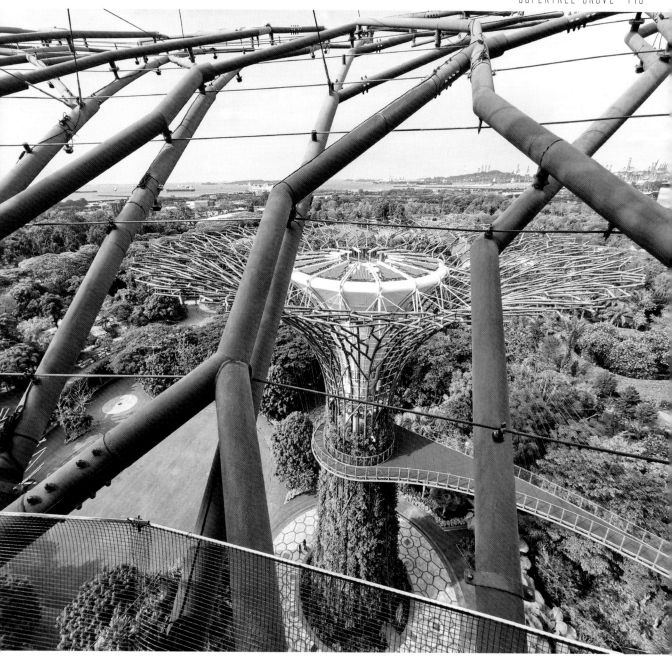

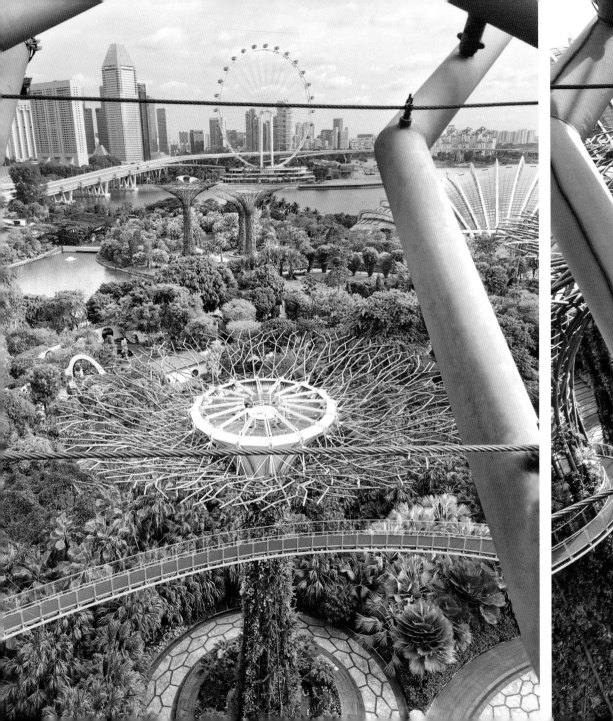

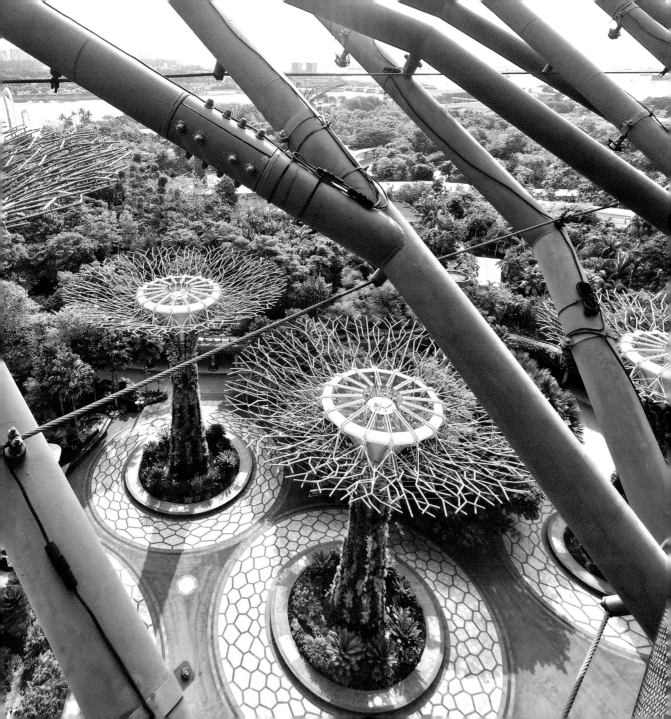

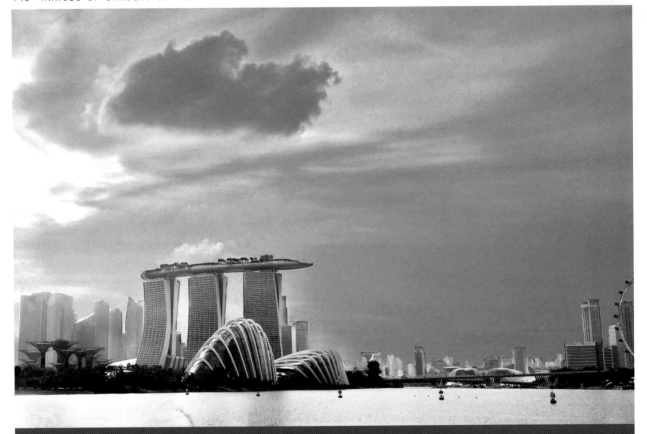

ABOUT THE PHOTOGRAPHER

Bernard Go Kwang Meng works in the creative industry and is a photo enthusiast. He spends much of his free time capturing images of what he sees around him; finding inspiration in street scenes, good food, well-designed items and exceptional architecture. This is his second pictorial album; he was also the photographer for the best-selling *Images of Singapore*.